THE
STONER BABES
Coloring Book

Katie Guinn

Microcosm Publishing
Portland, OR | Cleveland, OH

THE STONER BABES COLORING BOOK

For a catalog, write

Microcosm Publishing

2752 N. Williams Ave

Portland, OR 97227

or visit www.Microcosm.Pub

ISBN 978-1-62106-430-5

This is Microcosm #265

To join the ranks of high-class stores that feature Microcosm titles, talk to your local rep: In the U.S. **Como** (Atlantic), **Abraham** (Midwest), **Bob Barnett** (Texas, Oklahoma, Louisiana), **Imprint** (Pacific), **Turnaround** in Europe, **UTP/Manda** in Canada, **New South** in Australia, and **GPS** in Asia, Africa, India, South America, and other countries. We are sold in the gift market by **Faire**.

Did you know that you can buy our books directly from us at sliding scale rates? Support a small, independent publisher and pay less than Amazon's price at **www. Microcosm.Pub**

Global labor conditions are bad, and our roots in industrial Cleveland in the 70s and 80s made us appreciate the need to treat workers right. Therefore, our books are MADE IN THE USA.

MICROCOSM · PUBLISHING

MICROCOSM PUBLISHING is Portland's most diversified publishing house and distributor, with a focus on the colorful, authentic, and empowering. Our books and zines have put your power in your hands since 1996, equipping readers to make positive changes in their lives and in the world around them. Microcosm emphasizes skill-building, showing hidden histories, and fostering creativity through challenging conventional publishing wisdom with books and bookettes about DIY skills, food, bicycling, gender, self-care, and social justice. What was once a distro and record label started by Joe Biel in a drafty bedroom was determined to be *Publishers Weekly*'s fastest-growing publisher of 2022 and has become among the oldest independent publishing houses in Portland, OR, and Cleveland, OH. We are a politically moderate, centrist publisher in a world that has inched to the right for the past 80 years.

ACKNOWLEDGMENTS

This book wouldn't exist if it weren't for the bad-ass babes that participated. Thank you ALL for allowing me to render your likenesses and transform you into my vision of you as glorious stoner babes! I dove deep to learn as much as I could about all the humans here on these pages. Your beauty and strength is oxygen to me.

Thank you to my mom and dad for always supporting me even when I painted the weirdest, most repulsive shit ever. My mama evolved from saying "Why can't you paint pretty things?" to "She sees it as beautiful! And that's what matters." These 64 pages of BEAUTY are for you Mama and Dadio.

Thank you to my lover husband Jesse. There is too much to list here. You fucking rock my world and are the most bestest man friend a human can have. You're my dream come true. My heartsong.

Thank you to my daughter Ruby for keeping me alive. Your love fills me up and keeps me creating every single day. Your overwhelming appreciation for the world around you is oxygen to me. This is for you girl! Thanks to my non-blood daughter Greeley for challenging me in all the ways. Your strength and calmness inspires me and keeps me on my toes. I love you both more than the most magnificent sunsets.

Thank you to the most bad-ass publishers ever in the world, who are kind, patient, intelligent, grounded, experienced... All of the things! Elly and Joe, you believed in this dream project of mine and helped me bring it to life in the best possible way, and I'm so grateful for that!

Thank you Catherine Hiller, Monica Drake, and Lidia Yuknavitch. Your work motivates me to work harder towards my most creative and impactful existence. Thank you for believing in this book and for being gracious, inspiring, beautifully talented, and vigorous women. Thank you to all my winged loved ones who live in the stars and paint the sunsets for bringing me visions and stories to keep me in the moment.

Thanks to The Original Nomad.

My deepest gratitude to every human who's ever supported me, pushed me, believed in me even when I couldn't—especially when I couldn't or don't.

Thank you Holly Stalder for being my mentor as an artist and designer for so many years. xo

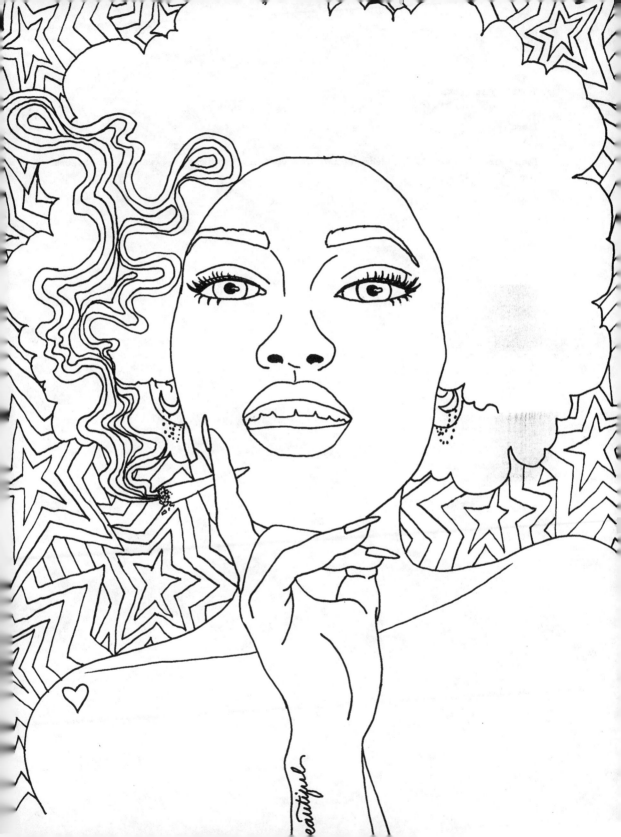

Genesy Rogers

Libra

Empowerment means being celebrated and supported on your journey to becoming your highest self.

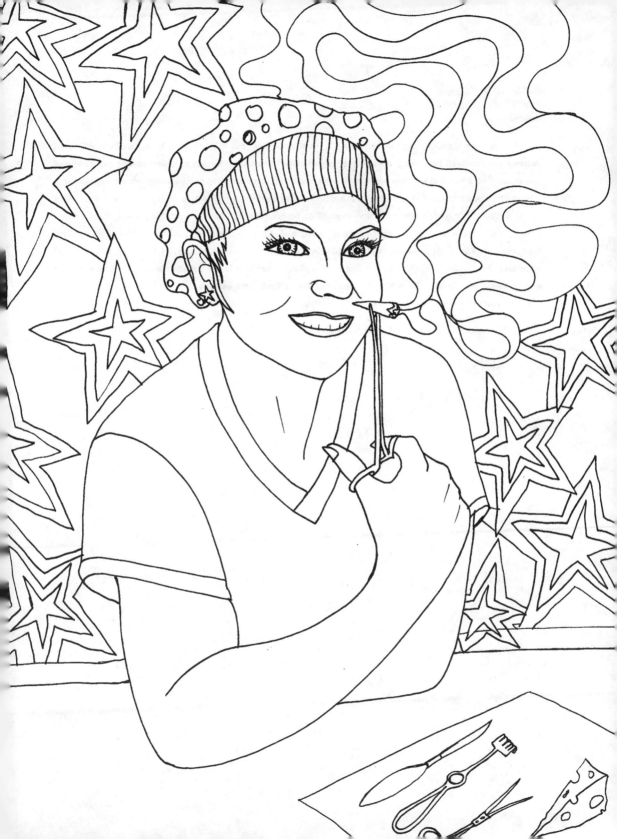

Amanda

Scorpio

For me, empowerment came when I finally realized that it is MY job to take care of myself. As I neared my fortieth birthday, awareness around my mortality began to move to the forefront of my thoughts. I needed to stop waiting for life to happen to me and take charge of my experience. I thought about what I wanted and started to give myself permission to honor those desires. I set standards for how I would allow myself to be treated by others and also how I would treat myself. I craved authenticity and stopped being able to go through with things that I was doing just because I felt obligated. I put boundaries in places where weakness had been disguised as courtesy. I felt like I finally grew a leg to stand on. I can say hard things now. I can keep myself out of toxic situations. I no longer measure myself against others. I'm not ashamed of myself (very often) anymore.

I traded wishes for action and that is empowerment.

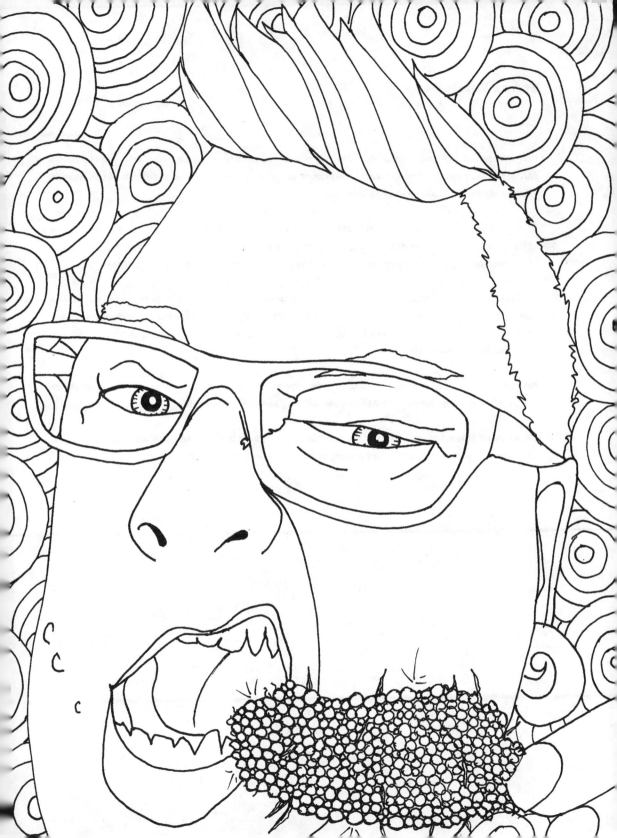

Stoner Boi Domi

Cancer

Empowerment is a broad term. My own personal empowerment is a matter of doing the best I can to have my external behavior be congruent with my internal beliefs about who I am. Simple answer maybe, but not so easy to achieve.

One of my goals is to try and meet people where they are, support them in finding what empowers them. A people empowered is a scary thing to people IN power. It actually helps those who get off on power to maintain control by keeping us at odds with one another. And it's working.

My work is all about telling truths that are hard to tell, so that we do not become or remain the story other people put on our bodies. I identify as a fat, masculine-leaning gender-fucking queer dedicated to not letting shit slide just because it's more comfortable not recognizing and calling out isms and problematic actions.

And in case you think I know any more than anyone else, let me assure you that I fuck up every single day out of ignorance. And that's ok. As long as I don't ignore it.

Get comfortable with making mistakes and doing your best to repair old, and build new, bridges. This work is not easy. Staying in tune with your true empowered you is key.

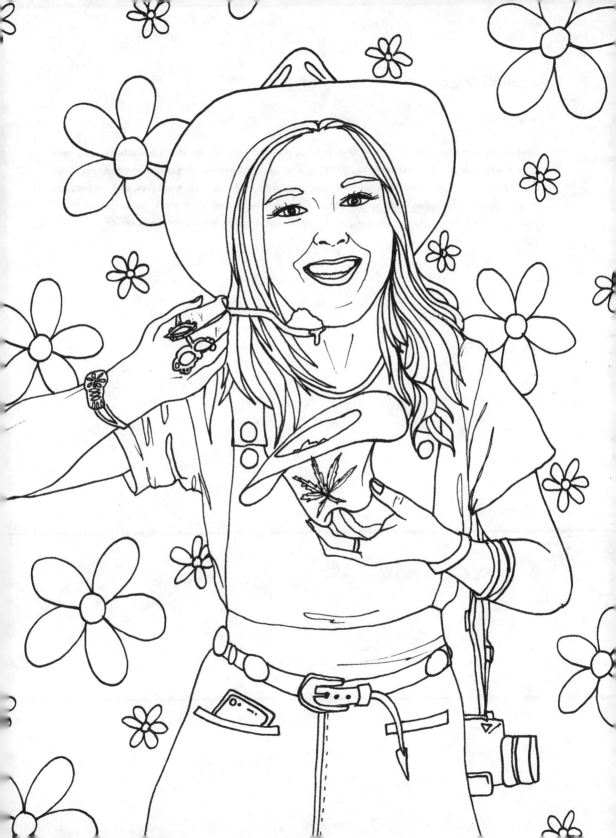

Amanda Leigh Smith

Sagittarius

Empowerment comes from within. It is owning your self-worth, self-determination and agency. I am greatly inspired by women, the LGBTQ, and the POC community and hope that my work and life exist in a space where I listen, learn, be an ally, provide love, kindness, and respect and where inspiration flows both ways. I hope that my work and life reflect the inspiration and admiration I have for those communities and reflect a space where they can freely and safely exist on their own terms.

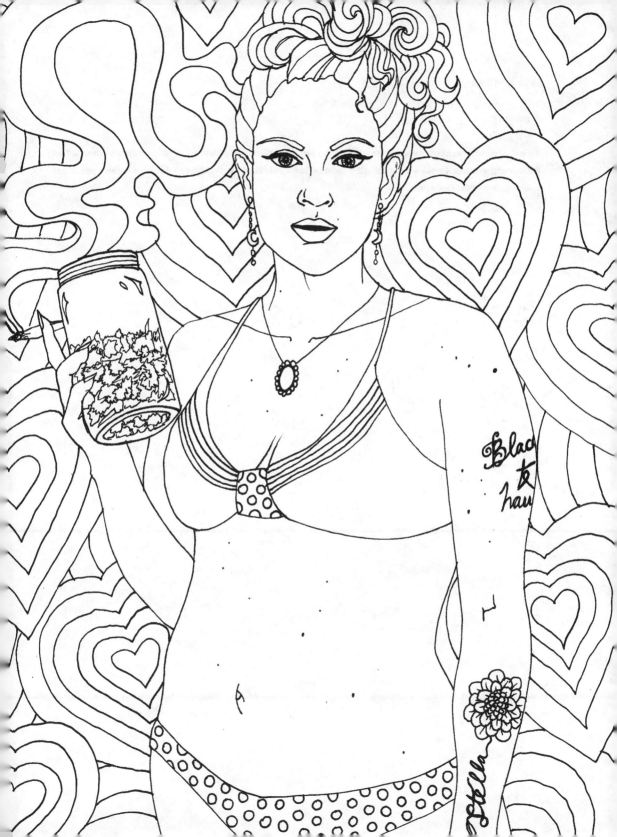

Aja Mehki

Aquarius

To me, empowerment means the ability to act on behalf of yourself and/or others due to the following means (one, some or all): education, spirituality, support from others, personal calling, personal beliefs.

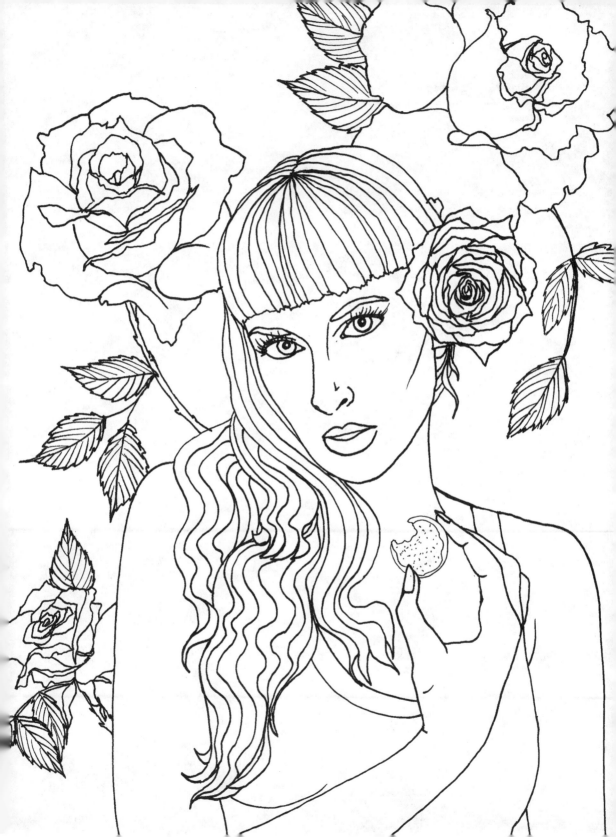

Anna Marie Cooper

Pisces

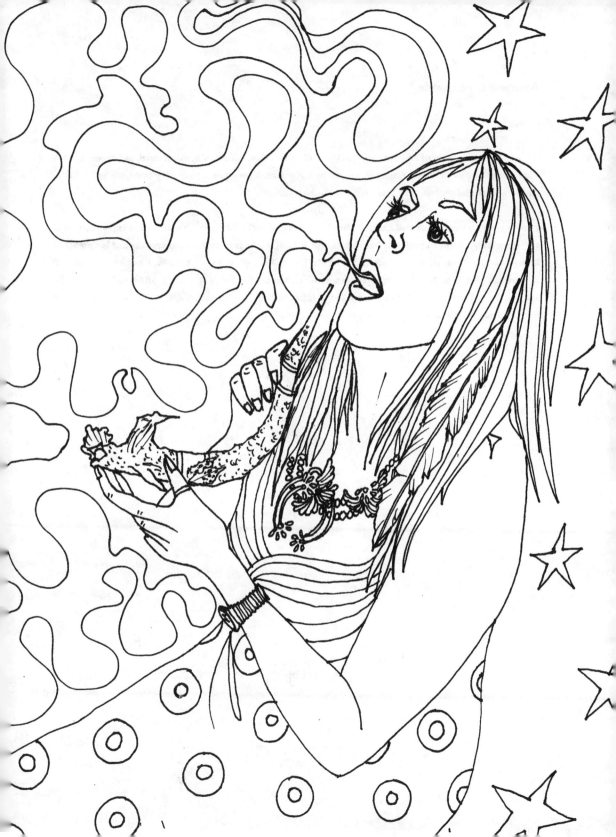

Annie Stark-Auda

Aquarius

I draw my energy from nature. My backyard is the Beavercreek Gorge. Huge pine trees. Lovely bird song. But as an Aquarian, I crave to be by water. I love the Ocean. My favorite spot. I love the sound of the waves, and the smell of the salt air.

I grew up by a huge lake and canoed the Pine River weekly. Rode my horse and skinny dipped in the Pine River. I am a spiritual being but think religion is just crowd control. I find inspiration from reading that woo-woo out there stuff. I see God spirit in all things. I believe we are all connected to add to this God spirit. I am a voracious reader but am legally blind so it's all audio all the time. I believe in living your life with intention. My husband and kids call me "witch," not because they are teenagers, but because I dream the future.

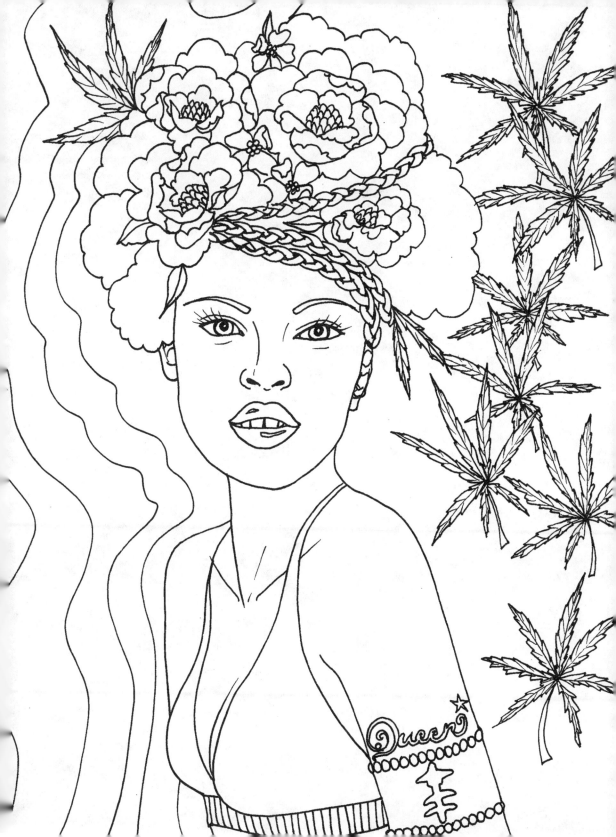

Queen

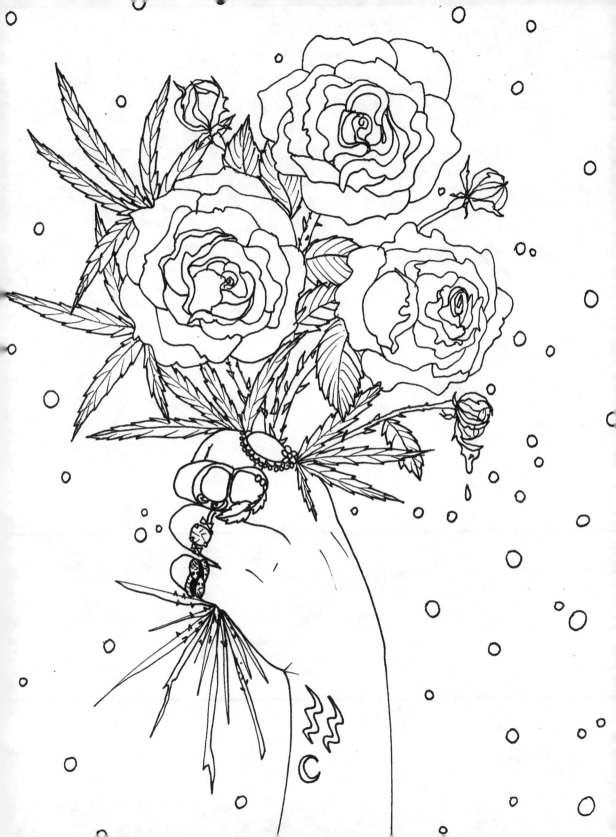

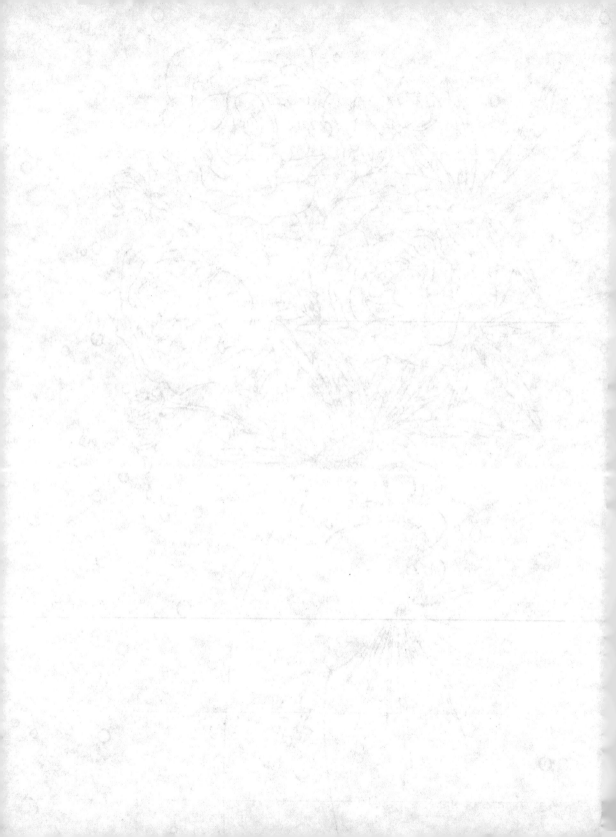

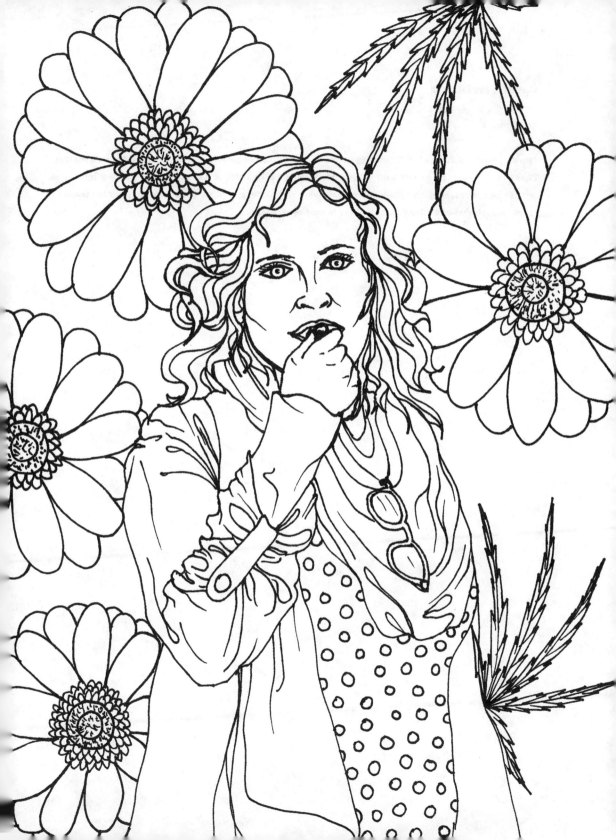

Carol Fischbach

Aquarius

Finding voice. Being voice. Standing in voice. The sound or tone or tenor of voice doesn't matter. There is strength in words and whispers. Words build volume and strength as they leave the arc of the throat, suspend themselves below your palate, use your breath to form gale strength force. Tell the world who you are. That is empowerment.

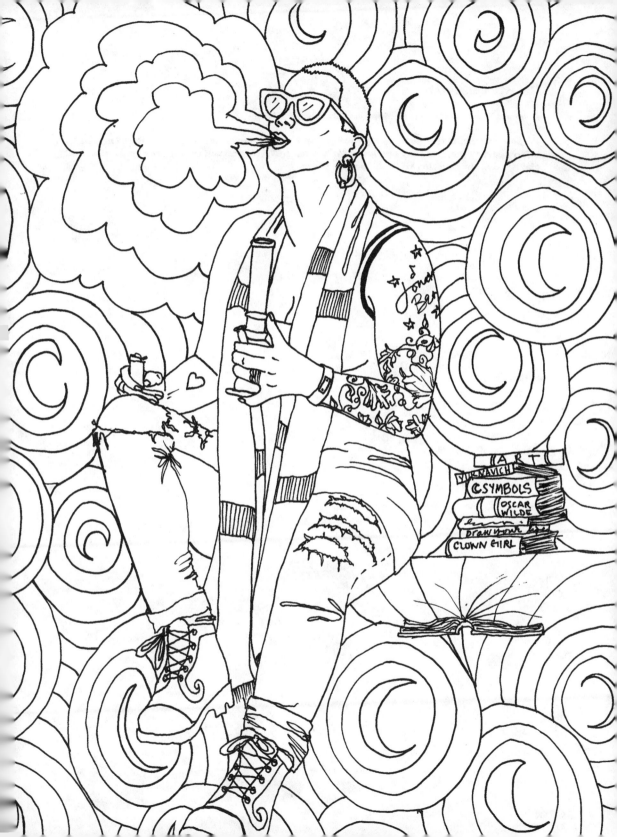

Celeste Gurevich

Bisexual Pisces with a Virgo Moon and Capricorn Rising

Empowerment, at this point in my journey on Earth, means rewriting the story of myself that others gave to me, and that I believed for too long. Writing myself into more compassion and clarity, and sharing this with the people I love.

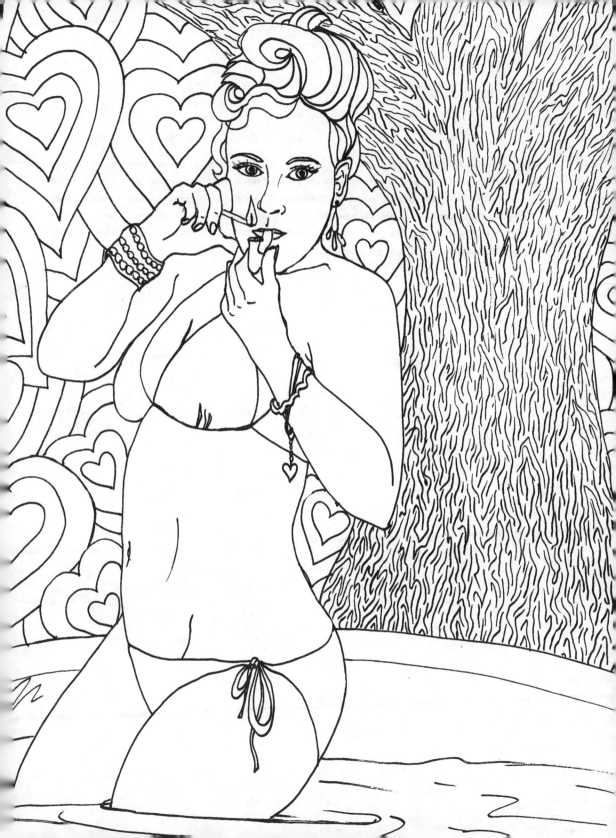

Danielle Meskill

Virgo

There is no higher form of empowerment than in the fulfillment of our individual possibilities. As a woman I feel incredibly lucky to have the rights I have today because we didn't many years ago. Let's live as equals and empower each other to be better human beings and work together not against one another. Judge yourself, not others because we are all different and have that right to be different. Live, laugh, love and dance like NO ONE is watching! Your life is what YOU make it!!! Live like you're being kissed by puppies everyday.....I try to.

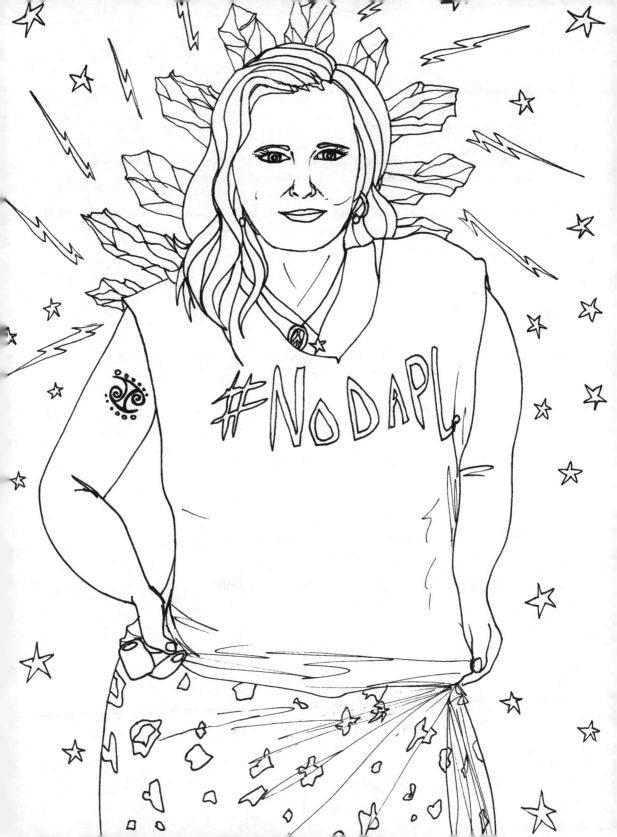

Desiree Wright

Moon, sun, and five houses in Gemini

For me, empowerment is not having to ask permission. Taking the open seat at the table. Empowerment is having choice, safety, respect, and no fear.

Self-empowerment is only the starting point. We have to pass it on. We have to open up space for others to be empowered, use their voice, take their seat at the table.

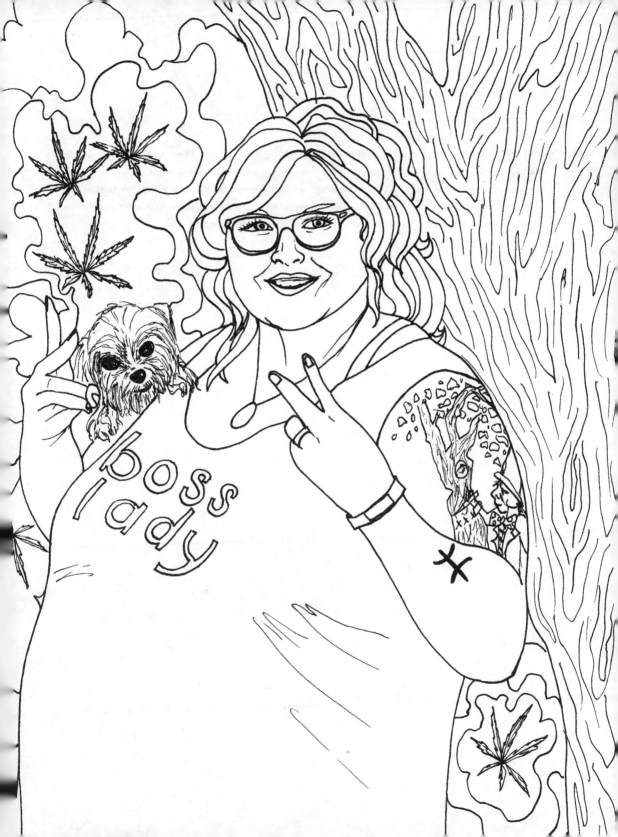

Edee

Pisces

To me, empowerment means unabashedly speaking your truth. For women, that sometimes means saying the uncomfortable, taboo things about our bodies and what is done to them by others in secret. My hope is that by telling my own story, whether in essays or fiction, other women will feel less alone, and will feel empowered to speak up. There is power in numbers. I believe wholeheartedly that we can effect change by shouting our truth.

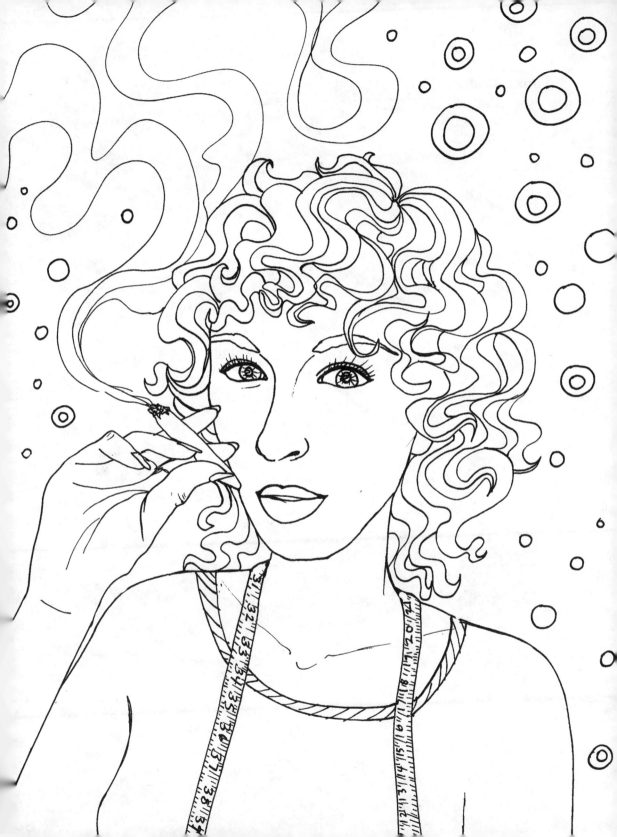

Julia Studer

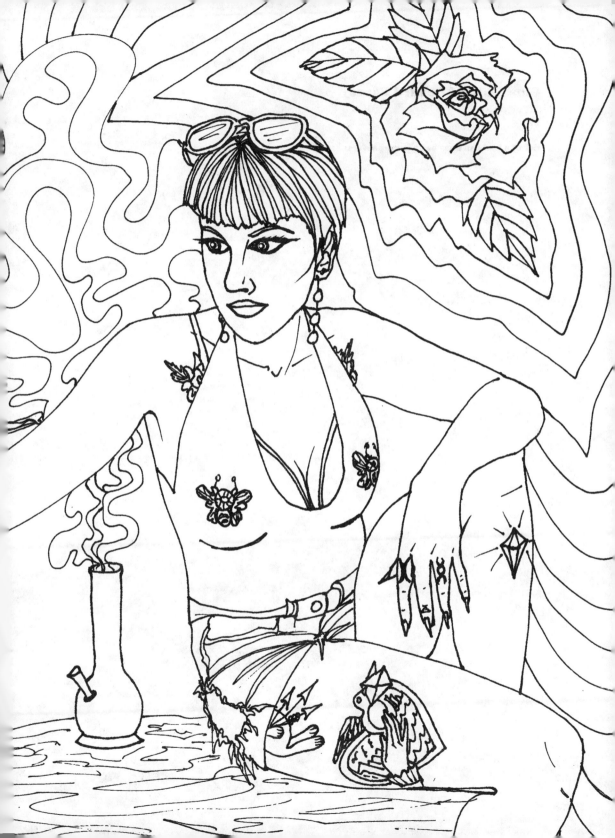

Gina (A.K.A The Bird Bones)

Leo

Being a bad-ass boss babe is empowerment to me.

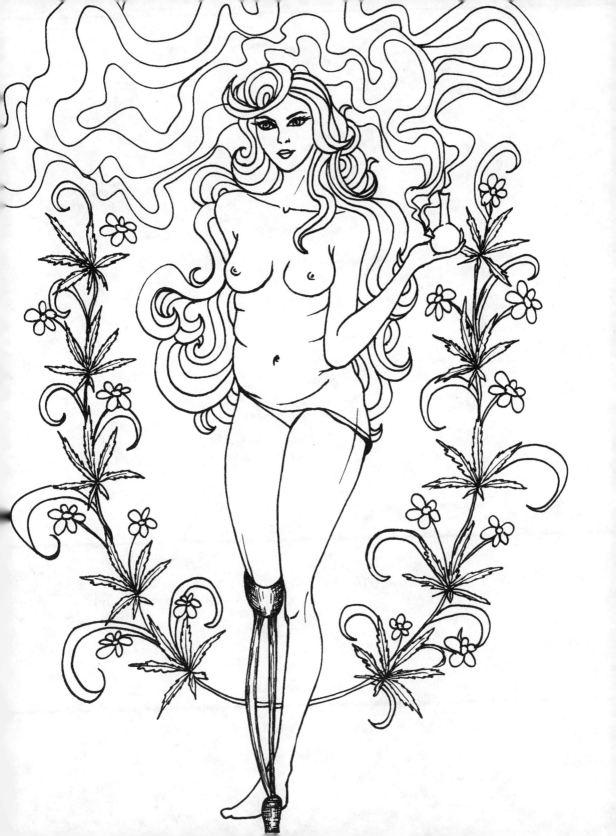

Goddess Rose

Aries

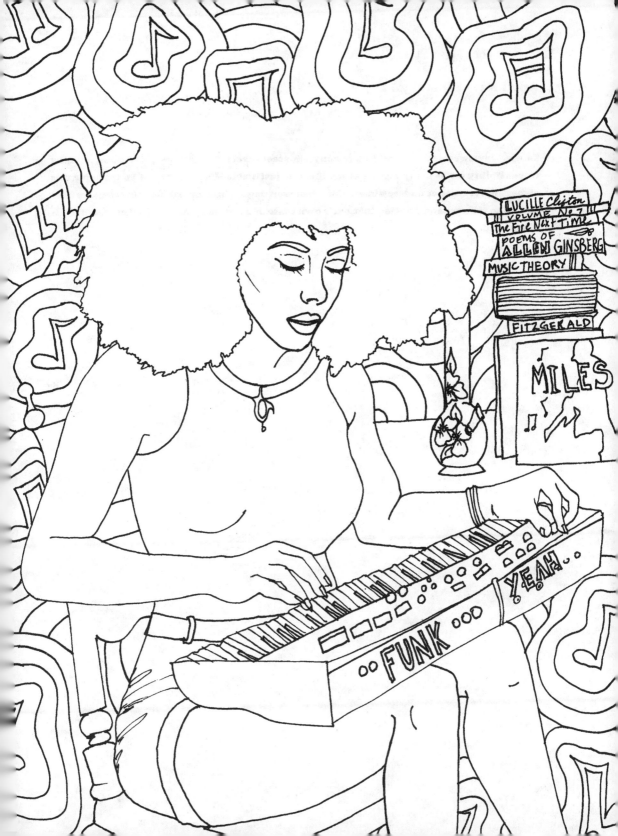

April Kae of Imanigold

Libra

To me, empowerment means holding myself accountable for my own decisions, owning responsibility for as many aspects of my life as is justifiable—but there must be space for this ownership. I must not underestimate the forces working against my self-actualization; I cannot be deaf to the predatory notion that one's own sense of purpose is enhanced when another's is diminished.

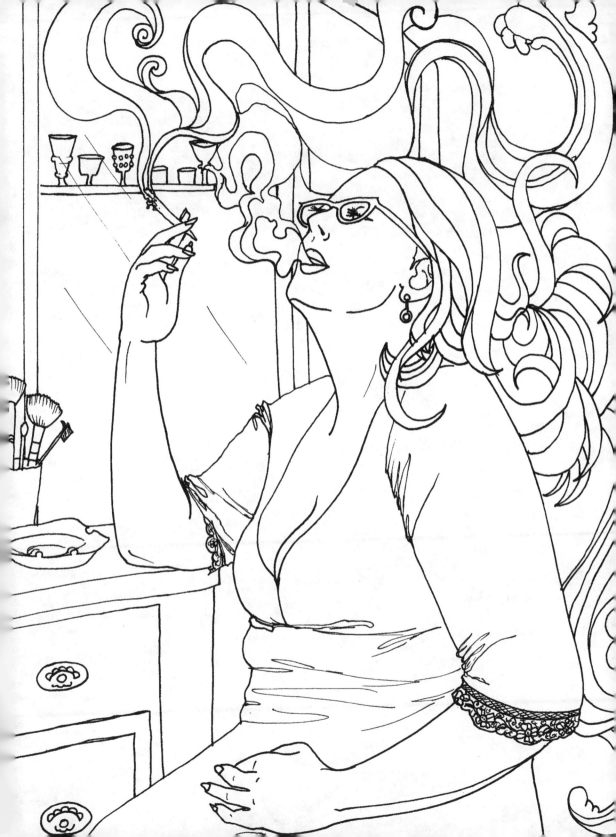

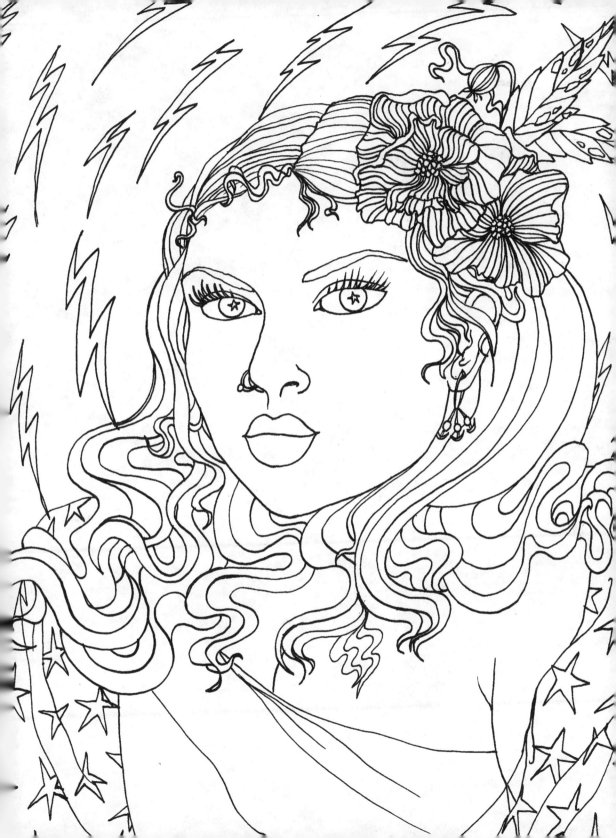

Janice

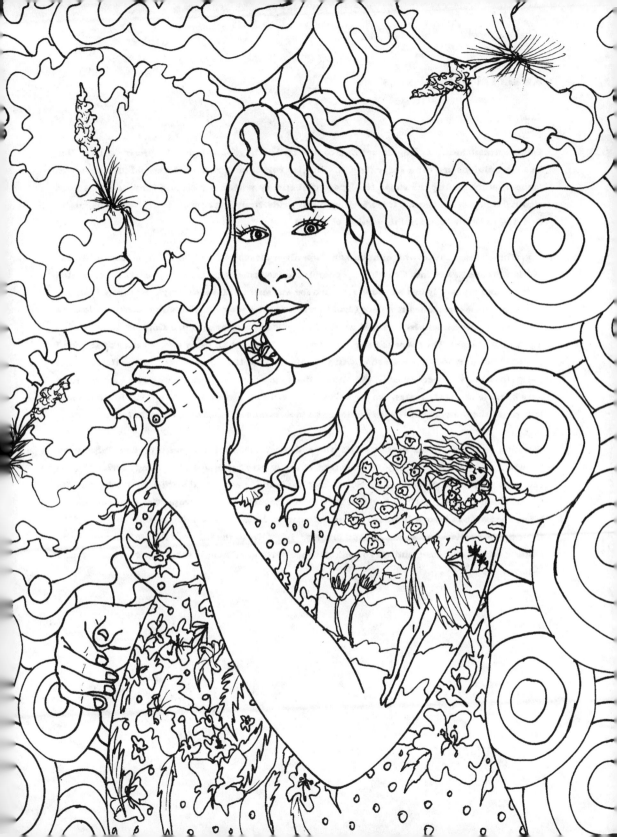

Ka'ala Lei-Maile Livingston

Taurus

Empowerment means having the courage to accomplish the goals I see as valuable. It means feeling like my opinions are valid regardless of who else values or agrees with them. Empowerment, for me, means feeling the strength of potential energy within myself and knowing that I can channel it however I choose. It is a feeling of self-pride, knowing I am currently and continually thriving to be the best possible version of myself.

I am a fun, honest and an outgoing person. I openly embrace and welcome people from all walks of life without hesitation. Growing up poor and mixed race was not always easy, we struggled at times and my family has had to work hard for our success. I worked my first job as a hostess at a local Chinese restaurant where I had to learn to interact well with all sorts of people from homeless to professionals. I gained a lot of knowledge and experience that set the path for my future careers. They worked me hard and long hours at an early age, which at the time I resented but now look back on thankfully. I now look for the inner beauty and gratefulness in everything I have experienced in life and realize I am who I am because of all it. I am stronger now because of the struggles, the stressful times and heartaches. I hope that the kindness and love that I show, regardless of the challenges I face, can be an example of how to treat others.

Working in the cannabis industry has allowed me to connect and build relationships with a variety of people. I have enjoyed meeting so many great people and sharing stories of how cannabis has helped so many of us. Whether it has helped people deal with anxiety, depression, insomnia, or physical pain, I truly believe in the natural healing properties cannabis has to offer. I'm excited to work in this growing industry and thoroughly enjoy helping patients with their needs. I believe in doing what you love and living life to the fullest. I find this happiness by helping others, traveling and surrounding myself with good people who inspire, support, and believe in me.

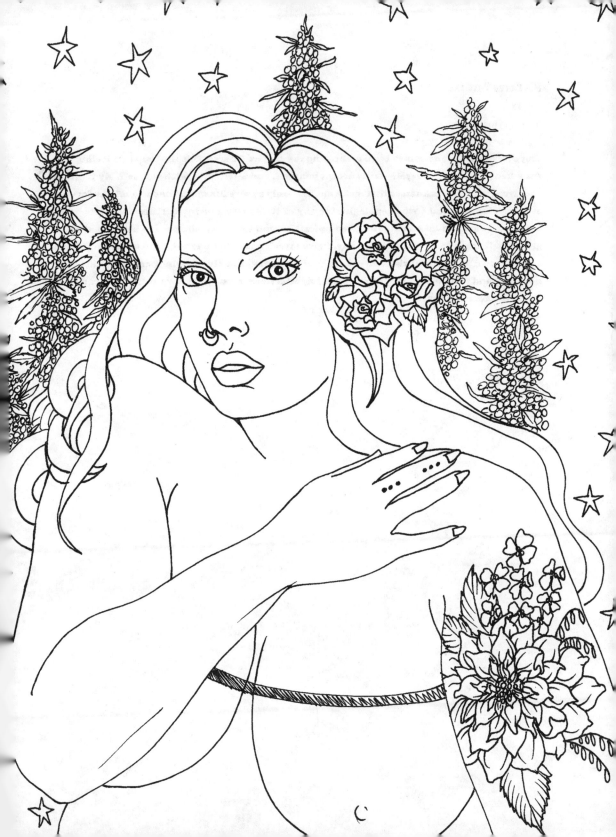

Katana Fatale

Virgo/Libra cusp

Empowerment for me comes from embracing my truths. There's this unstoppable feeling you get when you accept yourself—truly accept yourself, and fall in love with yourself. My truths—the strengths and weaknesses that make me, me—only ensure I'm multidimensional. I'm forever evolving, layered, and I wont apologize for any of it. My flaws or insecurities definitely don't define me. I am a human being full of complexities, and I give myself space to have a bad day, I give myself space to have a self-care day, I give myself space to be totally into myself and fawn over my own beauty and character. I am ever changing, but this is who I am right this very moment—and it's glorious in all its perfect imperfections. I am on my own team. How can I not feel empowered by that?

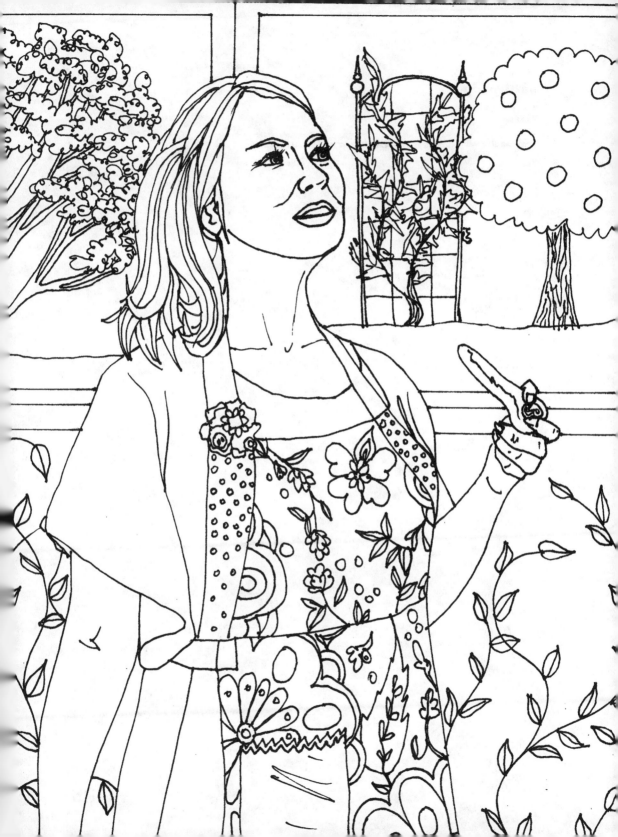

KatBrandu

Taurus

Approach every day as if it's a new world, because it is.

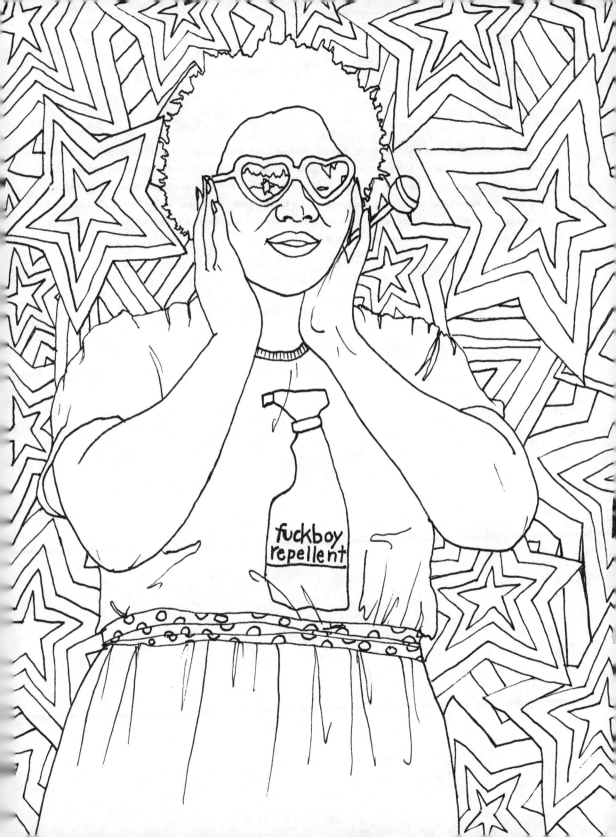

Kanda Mbenza-Ngoma

Capricorn

Empowerment means a lot of things to me. Most of all, I think it means radical attempts at self-acceptance. I think it's the most realistic goal for me. I think that showing up for myself and attempting on a daily basis to accept who I am in my most pure state is the most empowering thing. It's especially something that cannot be taken away from me. I also think that radical attempts at self-acceptance can be so contagious. I think that there is nothing more empowering than learning to truly see oneself every day.

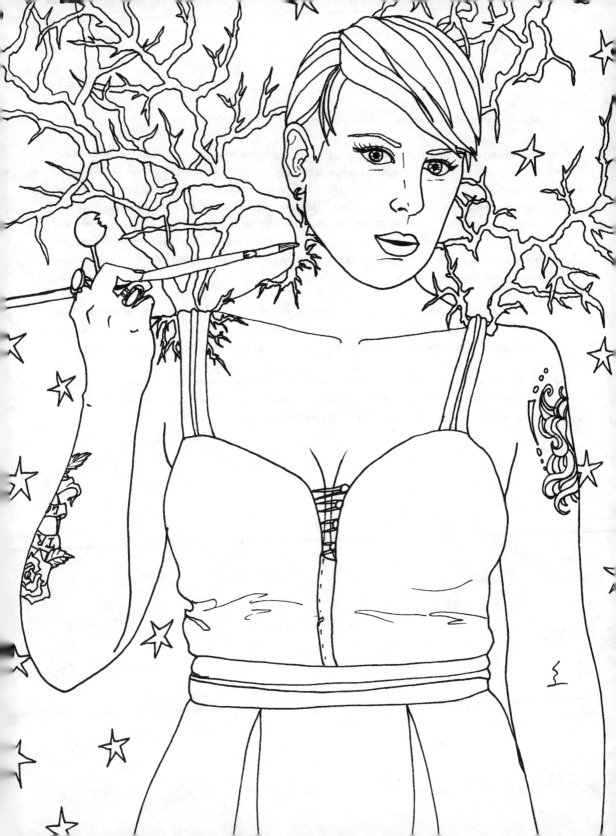

Katie Guinn

Aquarius with Gemini moon and Aquarius rising

The opportunity that this project has presented to work with a variety of humans has been one of the most empowering times in my life. I believe that every single person on this earth is worth seeing and loving. Empowerment to me means being there for the people we love and being their back-up vocals when they're feeling down or oppressed. It means appreciating every single moment I have; the fact that I have the option of not wasting one moment empowers me. Surrounding myself with strong, intelligent, motivated, loving humans is empowering because we can manifest epic shit together. Art, writing, dancing, listening and loving even those who may despise me is empowering.

We all have beauty to offer. I seek that beauty every day. It exists always in plain sight. All my flaws that socitey bestows upon me, women, people of color and disabled humans are the aspects that make us sparkle and open to connect with eachother, vulnerable and humble.

Processing all of my anxieties, fears, depression and horrific memories through art empowers me. Surrendering to those emotions and experiences, letting them escape my body and fall onto paper or canvas is empowering. LOVE is empowering.

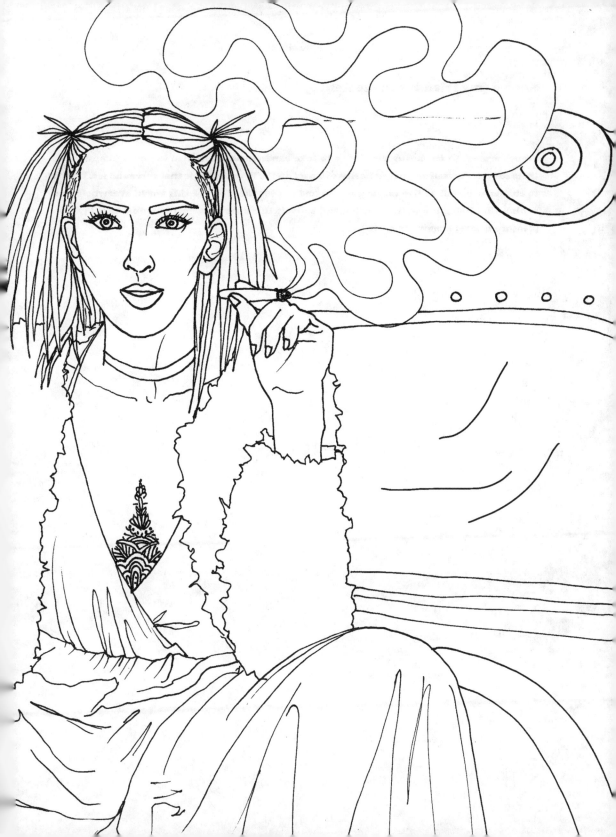

Kenzie (my friends call me Kenzo)

Leo

Empowerment to me means the ability to take experiences I have had in my lifetime and use them to better myself and have a positive impact on the lives of people that surround me. I strive to challenge myself to live in the moment and not let the chaos of this world overwhelm me. I think that living life with intention and actively listening to every individual that I get the pleasure to meet empowers me to learn.

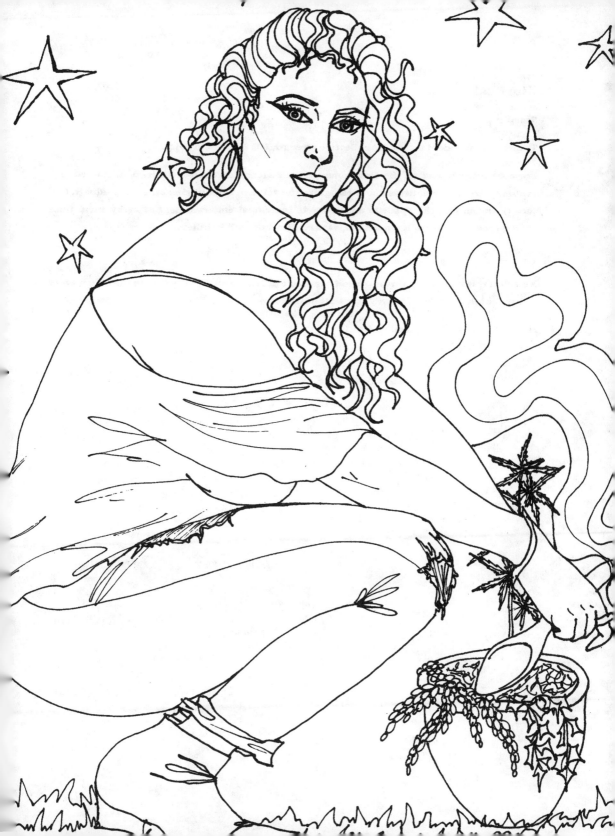

Kim Neal

Scorpio

To me, empowerment means the collective strength felt from inclusivity.

Empowerment is one of the first voices to self-agency and self-actualization. Empowered mammals are directed, driven, and recognize the value in empowering other individuals. Our society encourages the opposite and thwarts individual empowerment at every turn. Once empowerment happens, it ripples outward replicating itself in others.

• • •

Kim Neal was a spectacular woman and her magic pulses through every person she knew, every forest she inhabited and in every star that inherited her energy. She will be missed immensely.

November 9, 1987 — September 4, 2019

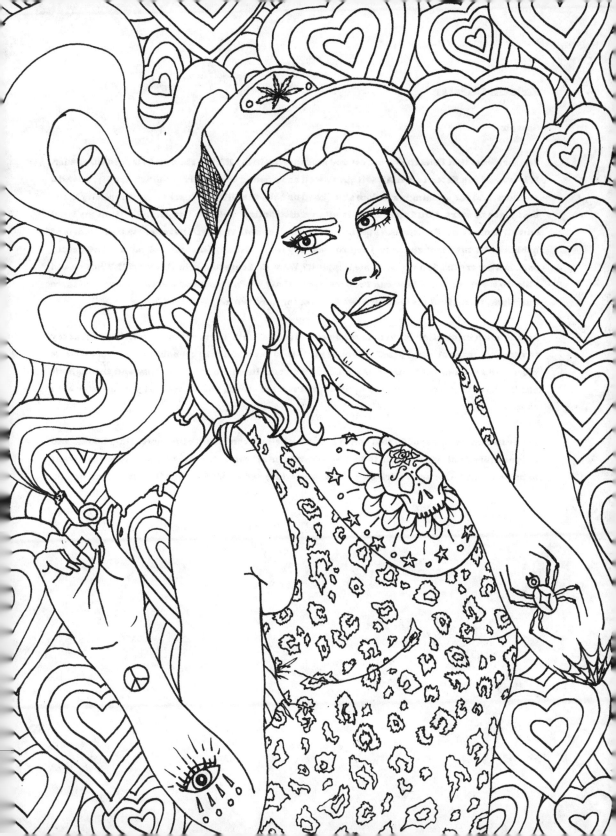

Kristin Currier

Scorpio

The moments that I feel the strongest and most driven in my life are those of balanced surrender. It is when I can listen to what's within as well as listening to my surroundings, family, friends, mentors, and the seemingly random shit (good or bad) that life reveals. For me, simplicity is the best place to start. I find that there is often a distracting dialogue happening within my head and all around me; Pressures, expectations, and/or doubts that will never cease their constant babbling. To cut through these, I try to clear my head (usually in a place of nature and peace) and find my truths. What makes me happiest? What do I care about in this world? What would I like to see change, and how can I contribute to that? When I hear and feel the answers to these questions, then I find my clear arrows to move forward with.

I see as much inspiration in this life as I do contrived bullshit. There are many constructs that try to carve an image of what people "should be." I find these today in schools, media, stores, work places, and various other areas of influence we come into contact with daily and throughout our lives. It's important to look and listen, but remain strong and know that you are your own captain.

I hope to inspire everyone in this world I meet by being a confident, open, accepting, loving, and unique individual. My desire is to be an environmental restoration and conservationist. I want to be a role model for smart driven women who strive and reach for goals that didn't previously seem achievable.

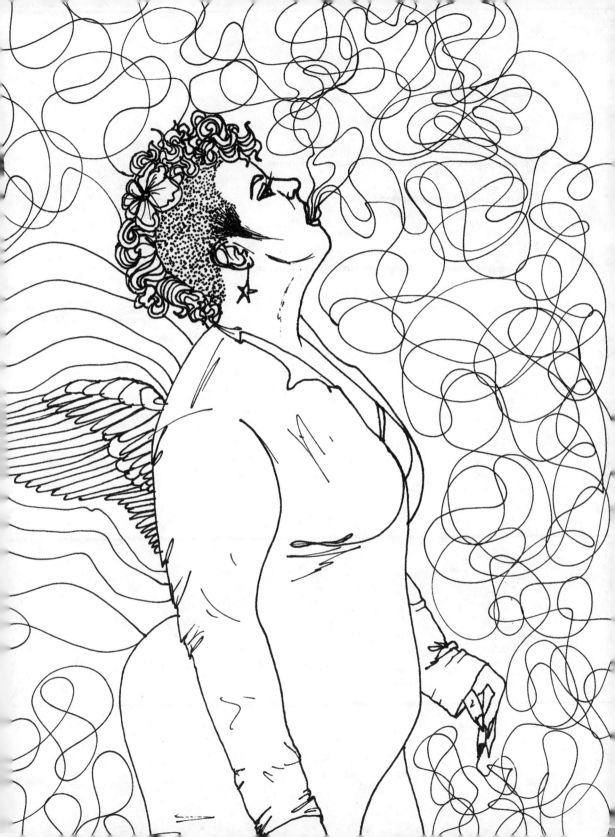

Lady Coquine

Gemini

It's empowering to see what my mind and body can do.

To step outside of my comfort zone.

To create, explore, and spread self love.

To push my own boundaries and physical abilities, to become the strongest I can be.

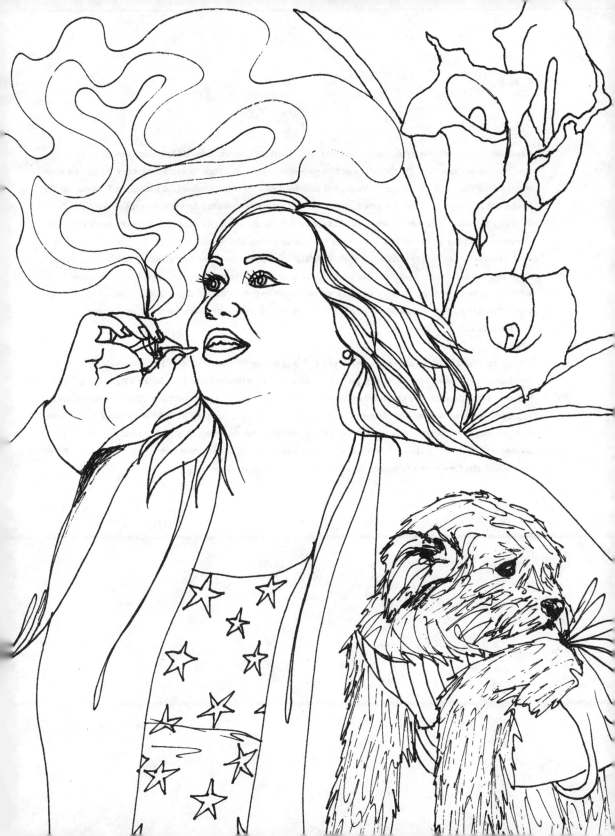

L.N.P.

Leo

I am most empowered by my past and the sacrifices my parents made for our family. 21 years of our lives were spent in "hiding." I am the youngest child of a family who migrated to the United States in 1991 with a visitor's visa and stayed after it was expired. As a child I never truly understood why my family wasn't able to go back to our country to visit or travel without fear. It wasn't until I was a pre-teen that I learned about my family's "secret" and realized how the decision that my parents made when I was 10 months old would impact my future education and career. I was angry with my parents, especially my mother for a long time for making a decision that directly affected my siblings and myself. I became a young girl who learned how to lie very well to protect my family. I wasn't able to get to know my grandparents before they passed, attain a drivers license, apply for financial aid/scholarships for college, or work at any job I wanted.

I soon realized that no matter how hard I thought my life was, it was no comparison to what my life would have been had my parents stayed in our home country. After 21 years, I finally became a resident in the United States and felt like I could finally start my life. I strive to make my parents proud of the decisions I make everyday so they know that the sacrifices they made for me were without a doubt the best decision for their family. My childhood empowers me to become the best person I can be. I never allow myself to forget where I came from and the sacrifices that were made by my family to give me a better life.

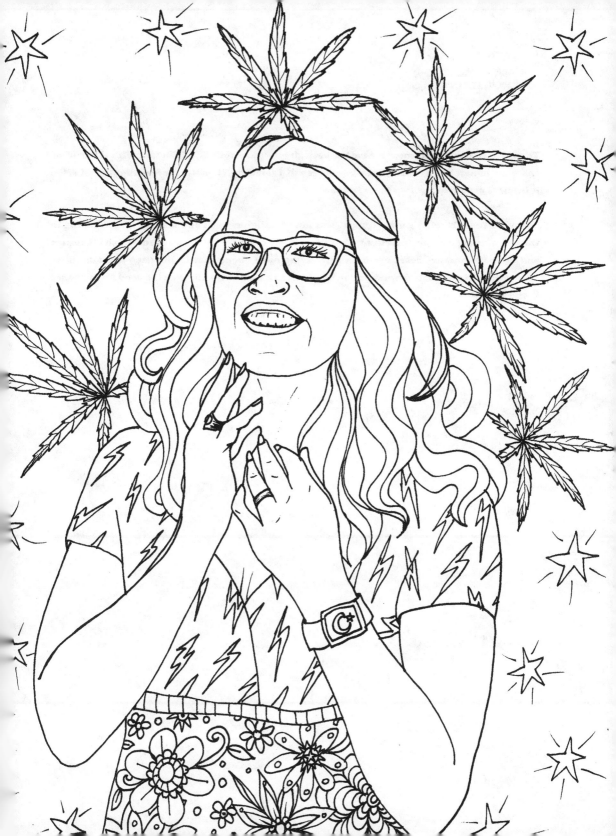

Mama Winters

Pisces

Turns out that empowerment for me has been about vulnerability. If I can say, "This is hard," or share my honest and probably messy feelings with someone, it makes me feel mighty and often it inspires people to open up to me in turn.

I thought that claiming empowerment was about building walls and making myself strong in the face of negativity or uncertainty, but it's just the opposite for me. I am human and feminine and my body and my heart are both soft. Being open about that in life has forged so many connections in my creative work and in my work as a human trying to be the good I want to see in the world.

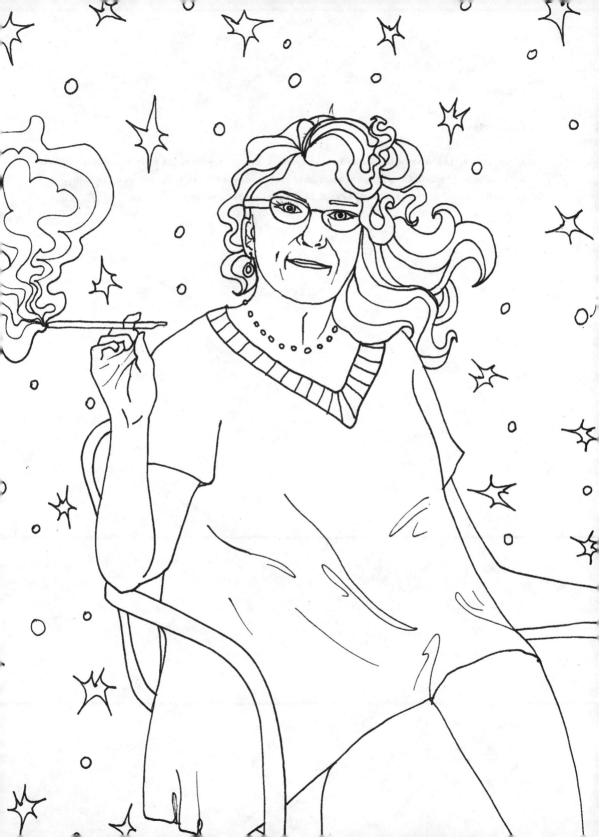

Mary

Sagittarius

It matters to say what's true, not in unkindness, but in un-censored-ness. It matters to take actions, mostly small, to applaud what's good and change what isn't. Empowerment is love—not the fluffy sort, but the hardcore, take-it-to-the-mat sort—in action.

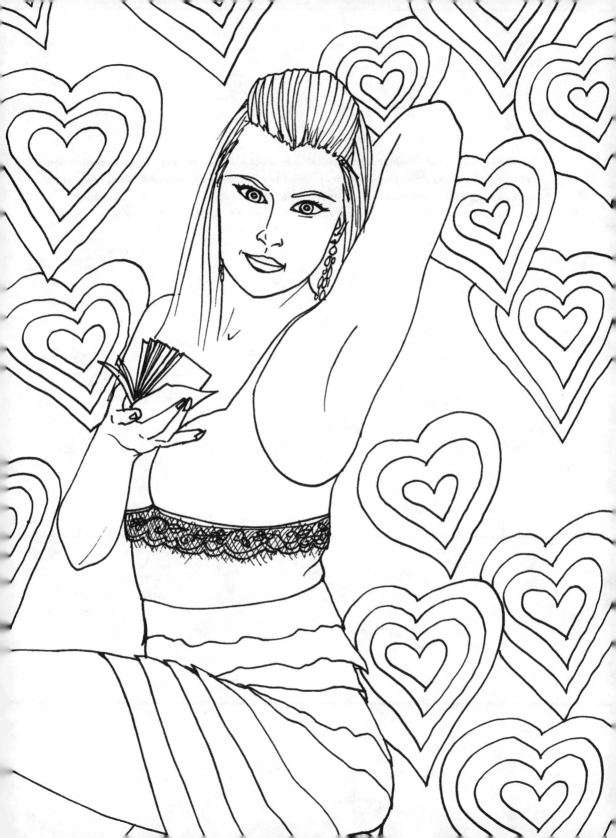

Megan

Gemini

Empowerment.... is it wrong that the Gemini in me thinks that word can mean so many different things? As I get older, the first thing that comes to my mind is being comfortable, in my skin, my body, my mind. I don't care what other people think about me or my choices anymore. I am empowered by knowing who I am as a woman. I'm a mother, a friend, a lover of words, a lover of love.

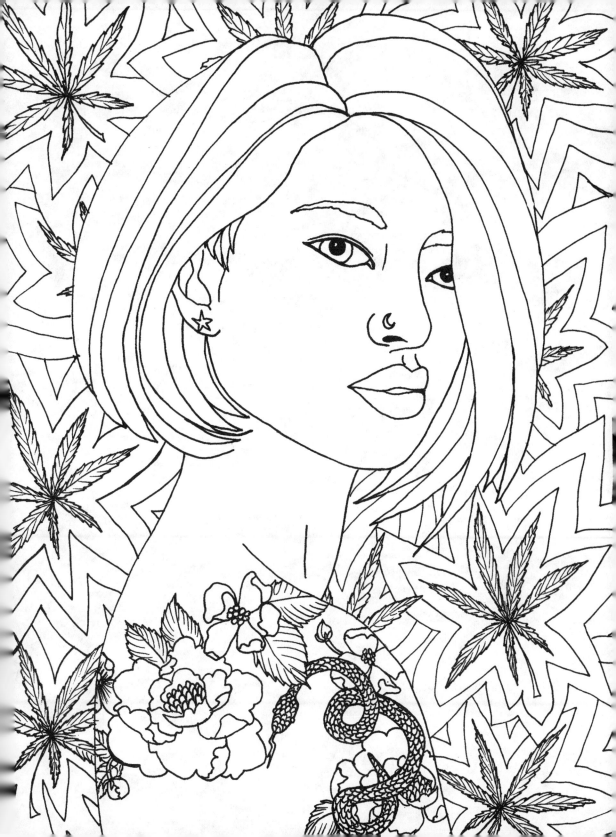

Mira

Sagittarius

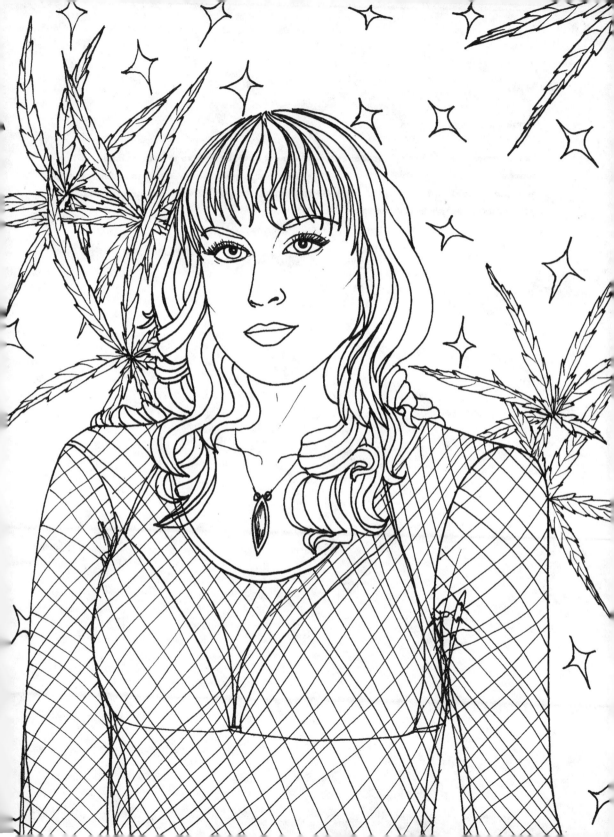

M.J.

Gemini

Empowerment is having options. Money is the most obvious way to attain options. I've spent most of my life trying other methods, but my new jam is about breaking glass ceilings, getting well-paid work, and helping to get well-paid work for others who can help diversify the population of people in the world who have options.

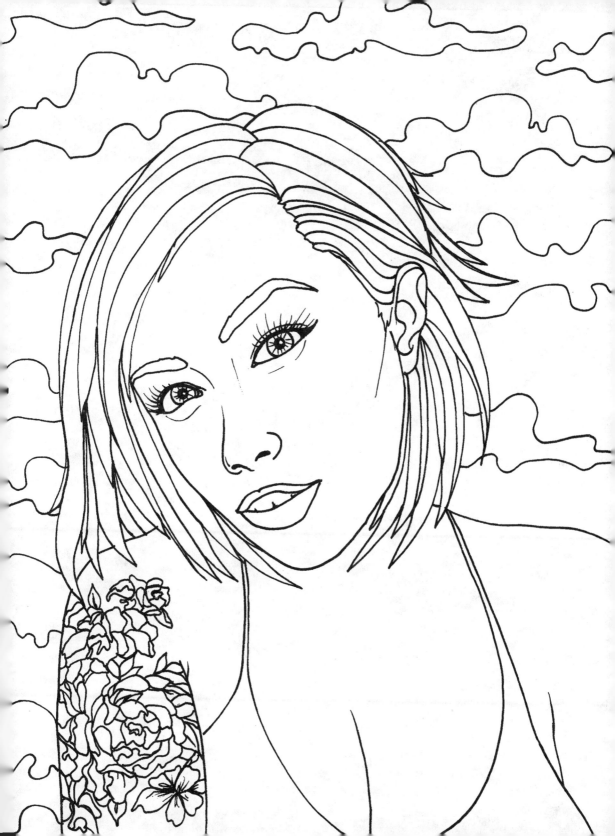

Paige

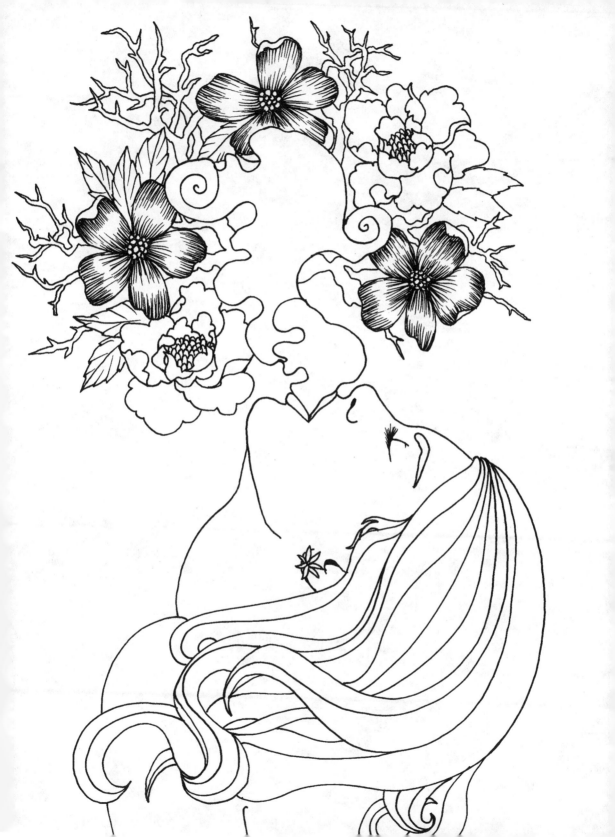

Petunia

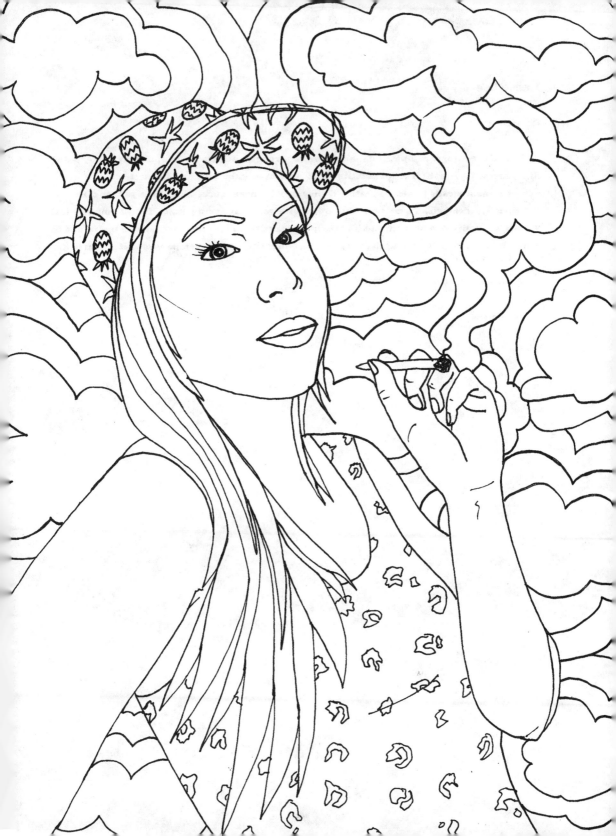

Reese Lee

Capricorn

To have the courage, compassion, and desire to strengthen someone else, despite the existing differences, and with the possibility that you may gain nothing from it—this is what empowerment means to me. No matter if they may be more "successful" than you, or different biologically, ideologically, or somehow otherwise radically from you, or if you yourself feel wholly unqualified to help anyone. To push past the self-doubts, whether yours or theirs, and to either find or create the strength to make them better—this is what empowerment means to me.

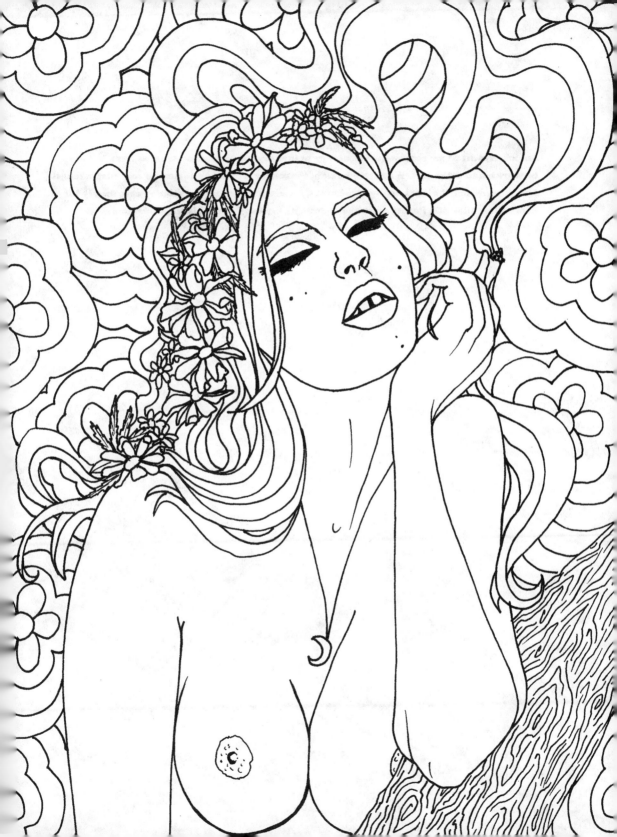

Sage

Sagittarius

Empowerment to me represents the ability to love myself deeply and truly as I am, but always be working to make myself a better human, a stronger woman and friend. From that strength I must work to lift others up always. Lovers, haters and indifferent people I care deeply for or pass on the sidewalk. Posing nude and embracing my body as it is, is empowerment.

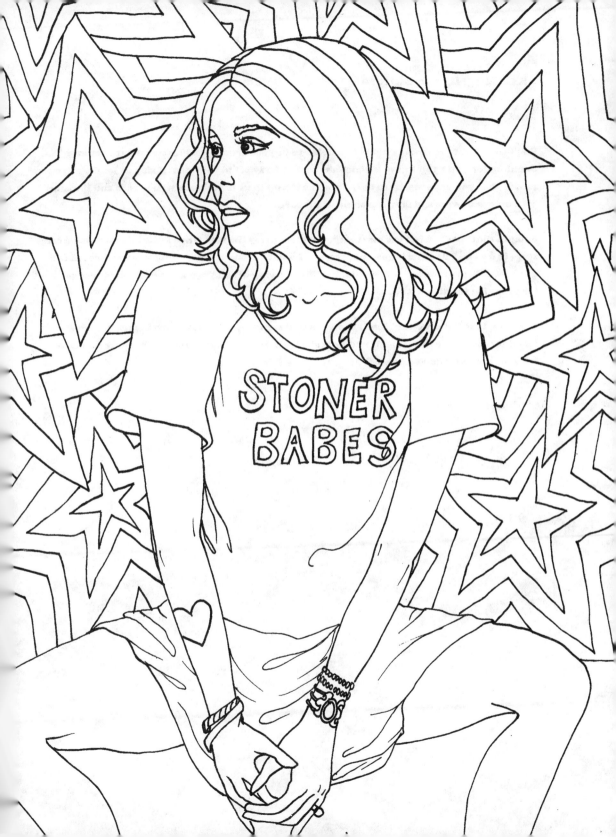

Skye Sengelmann Sintora

Aries

Empowerment to me means not being afraid to be your true self no matter what that may be. Stand up for what you know is right, show your body off in confidence, sing as loudly as you can, be who you were meant to be. As women it's up to us to embrace who we are and find our own unique powers and let them shine without fear.

Some of the times I've felt the most empowerment in my life was when I was a dancer. Being on stage in a room full of strangers, not scared of what anyone thinks, doing what makes ME feel good regardless of others' judgments. It's like showing off all your insecurities and just going for it; taking the dive without looking back.

And now that I'm a mother, I will continue to live in ways that make me happy, teaching my daughter to embrace who she is and how she feels. Her support team will be there no matter who she grows up and becomes.

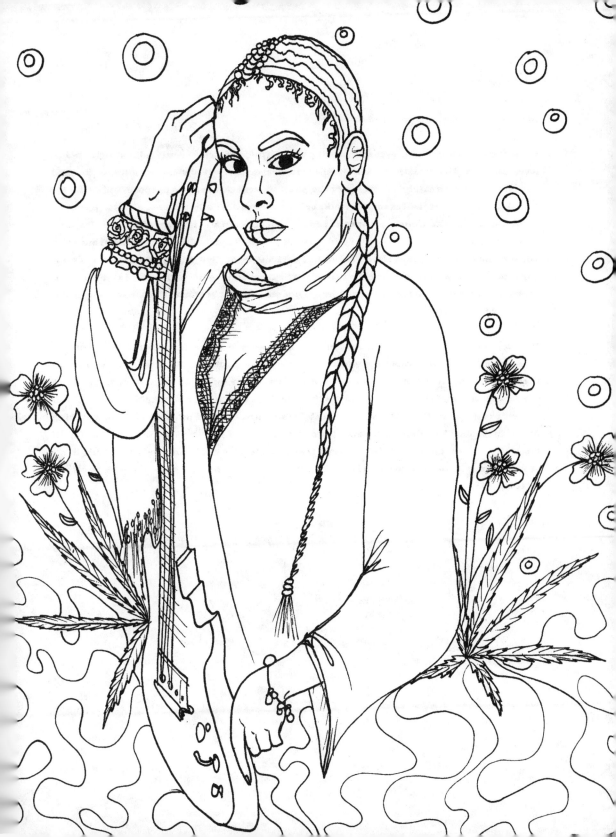

Sy Sylvers

Sagittarius Warrior/Queen/Goddess

Empowerment through my eyes means being an uplifting auspicious soul leader of light, peace, love, understanding, creativity, knowledge, encouragement, uniqueness, equality, source and power. Also, being a catalyst to making others feel supernatural with a purpose And desire for ones destiny to come true. Letting all walks of life know you are allowed to be a masterpiece and a work of art simultaneously. I want the people who inspired and influenced me to be inspired by me because we are all one and everything is a remix. We're all looking for a home of our own, when home is in our hearts. Have a childlike heart and be patient with yourself and don't put any expectations on anyone. Face the future without fear and walk with faith. I want to be an exuberant force through my music, making people see good in the world, themselves and others, despite corruption.

My purpose is to heal the world and inspire the masses in all communities. Due to current changes and events all around the world the human race is suffering tremendously and we all need LOVE!!! We are a dying nation without a heartbeat or pulse. We are lost, angry, sad and frustrated looking for leadership During these corrupt times, Not realizing We are the global leaders of our generation and we need a REVOLution and to stand up, not just with Marching but with Action. Just like the greats before our time paved the way with one purpose for all humanity. We are all BeYOUtiful in every shade, shape, size and in our beliefs. In this life, I vow to give art from the heart and be a Distraction of Love. Blessings and miracles to all the BeYOUtiful faces of the world.

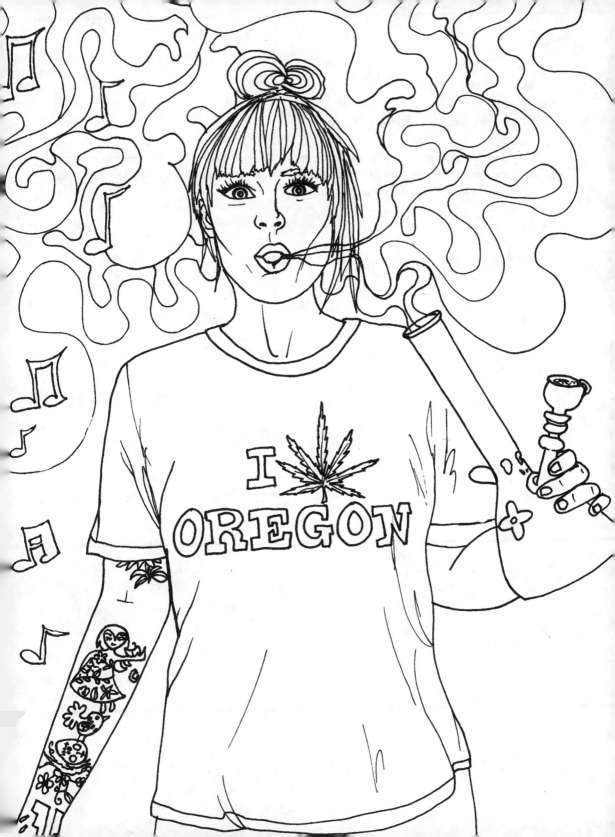

Zia McBabe

Gemini with Aquarius rising & Pisces moon

To me, empowerment means: Inner strength, confidence and the freedom to make my own decisions. To go through each day honoring my own truth, happiness and safety while lifting up and being uplifted by the people around me.

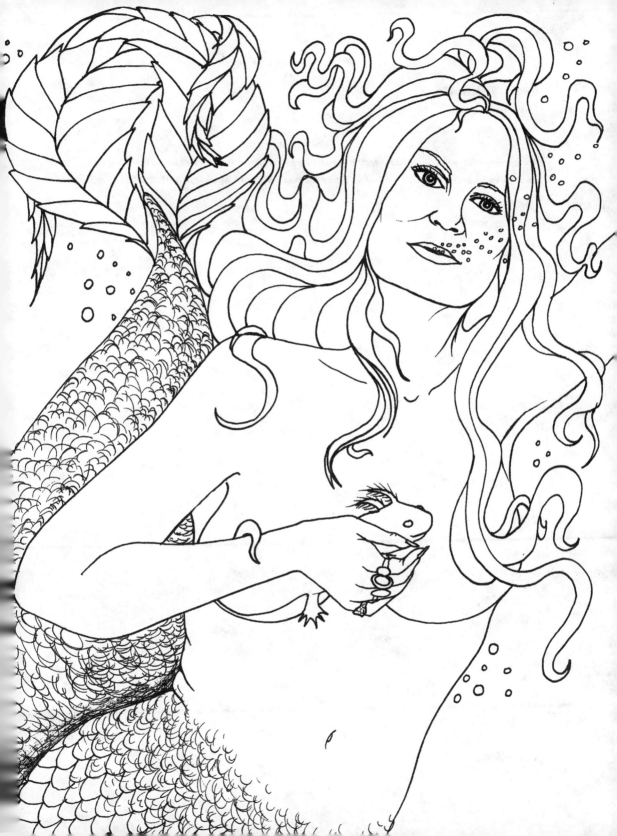

Lidia Yuknavitch

Gemini

To me empowerment means unwriting and rewriting the cultural stories of identity and agency that have inscribed us and buried us since forever. Without apology. With teeth.

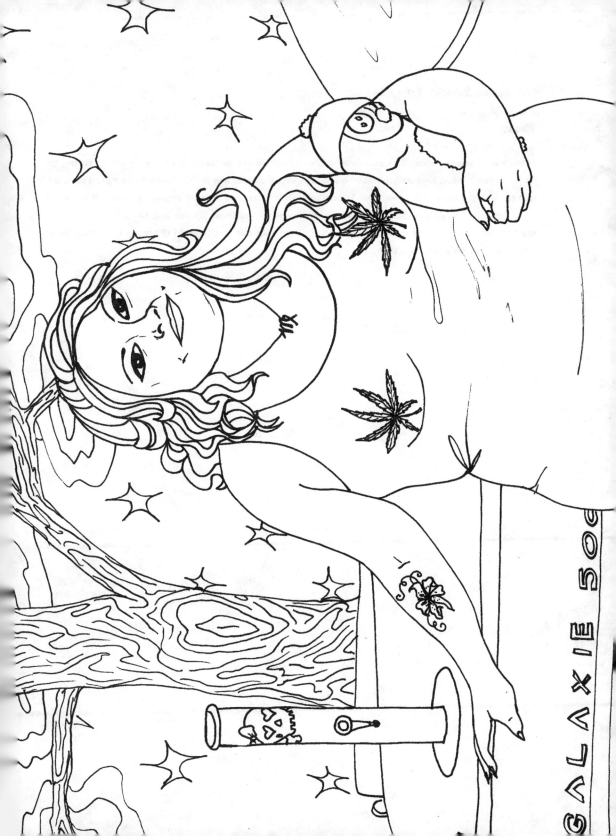

Orgazmic420, D, Lady D

Virgo

I think of empowerment as a stairway to evolving. We are constantly changing and striving to do better and learn something about ourselves every day. Being comfortable in our own skin no matter what walks of life we have been through is what unites this world and still diversifies us to be our own unique selves. My empowerment comes from loving and accepting myself in my journey of being a human. I cannot ask for a greater gift to life and I show my gratitude each day by living my life to the fullest!

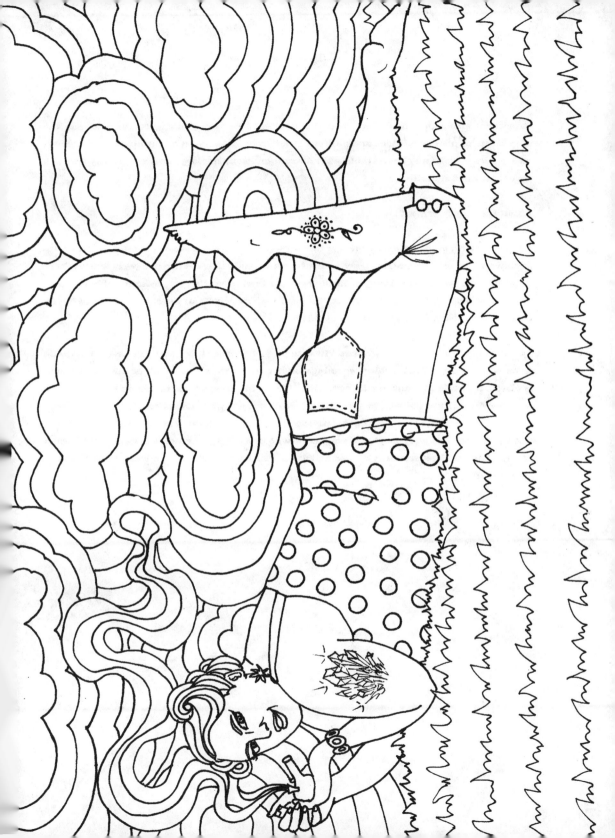

Katie O

Capricorn, although I don't buy into the woo-woo. No way you'll ever convince me the alignments of planets millions and millions of miles away had even an infinitesimal influence on my personage in any conceivable way. Astronomy, not astrology! But, apparently that is a very 'goat-like" attitude.

About this empowerment issue...

I've having a bit of hard time answering this prompt. Frankly, I'm scared, absolutely, wake-up-in-cold-sweats, to the core frightened of the turn ours and other countries have recently taken. I feel like the world was finally making progress toward getting its collective shit together when WHAMMO! I'm reeling and incredulous at the sheer cruelty of the changes enacted by the current administration and it's only Day 2 as I type this.

But, damn it, I am an eternal optimist. I have to be: I am mother to a spunky, loving, empathetic 3-year-old daughter. That whole "becoming a mum changes your view" ain't no joke. This mama is pissed. If you don't want to take responsibility for the mess we've created on this planet, go live elsewhere. I was raised a proud leftist. I can't sit on my bodacious booty and mope about this. I have marched, I am resisting this nationalist government, I will recycle like a speed freak with OCD and hassle my lazy bum neighbors who don't, I will preach kindness, I will teach science, and I will get seriously stoned and dance like a maniacal go-go goddess when I need to escape it all.

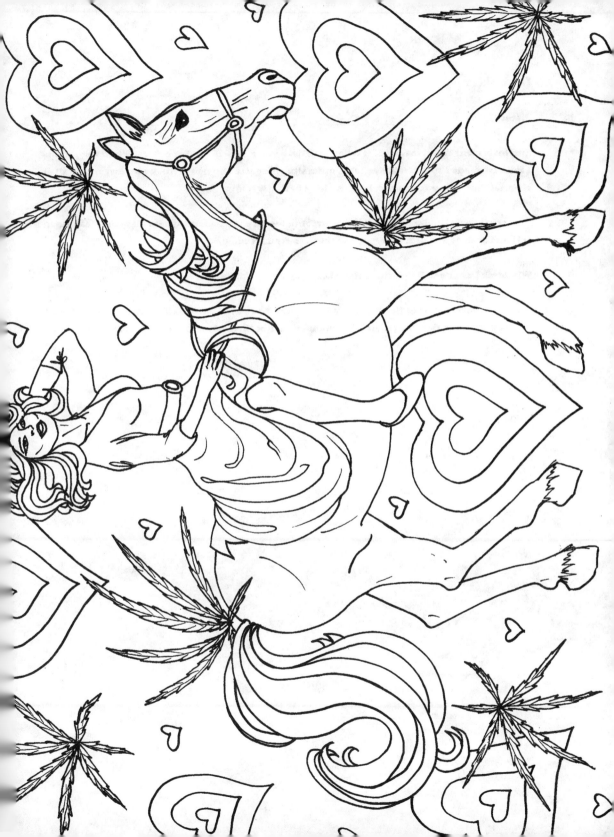

Leah Baer

Pisces

Empowerment is active love. It is what I can do, not for myself, but for others. Whatever actions I take & words I speak which enable others to recognize the power they possess, and to then channel that power for themselves and for a better world.

 It is whatever I can do to create—or contribute to—an environment where all people can learn & flourish, & reject all that oppresses them, & find freedom.

Whatever I can do to help others find their way out of darkness.

Albert Camus wrote: "In the midst of winter, I discovered within myself an invincible summer." Helping others to find that invincible summer within themselves is my idea of empowerment.

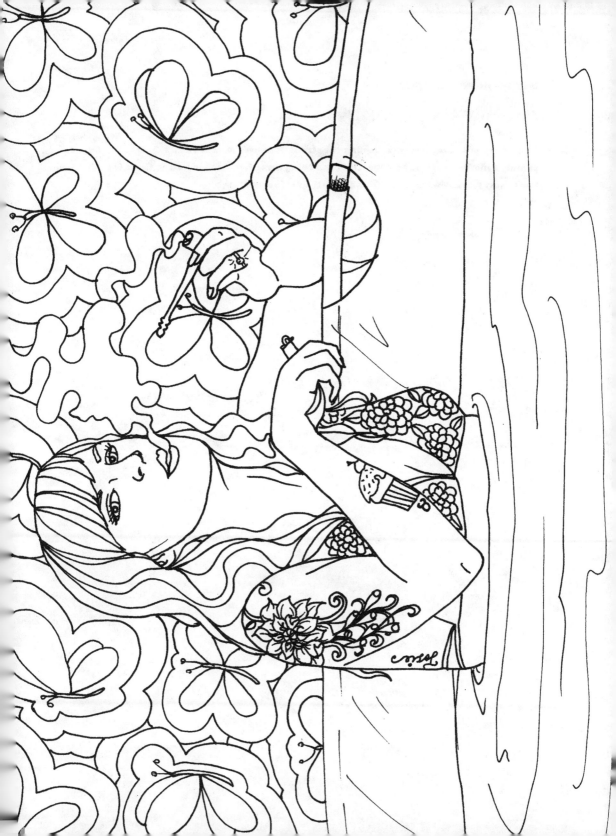

Sarah Morris Kemper

Taurus

Empowerment to me has been finding the strength to overcome my fears. Fears of failing, becoming a mother, getting an education, and being myself, no longer letting those fears hold me back...sorry, what where we talking about? I'm stoooned!

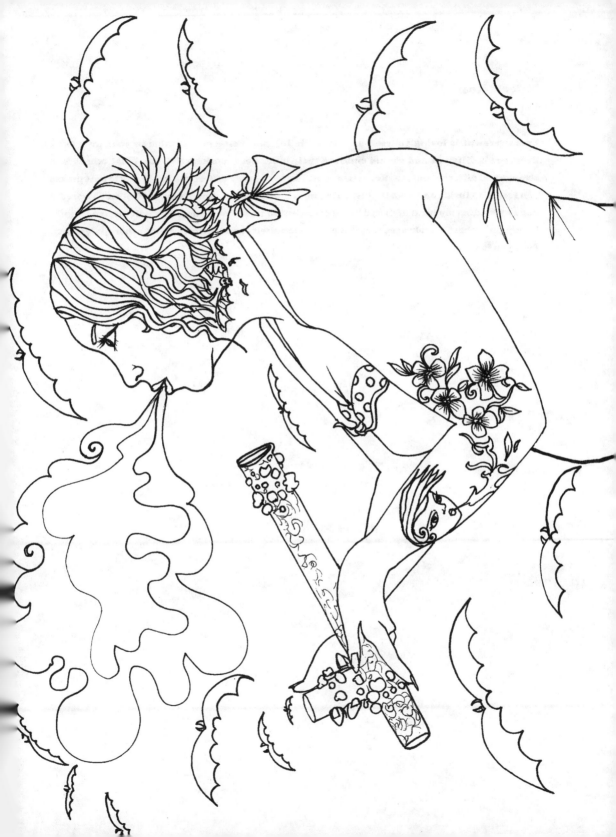

Valerie Rose
Leo

Empowerment is loving yourself and your life for you. Being comfortable in your own skin. Everyone is different and should embrace their inner nerd, dork, artist, etc. What others find strange and different only makes you unique. Listen to every different kind of music that makes you feel good inside and own it. Just being myself untamed makes makes me feel empowered. I hope by holding my head high and being confident in myself everyday, this will inspire friends, family, and others to embrace everything about themselves and not care about others judgments. Love you for you .

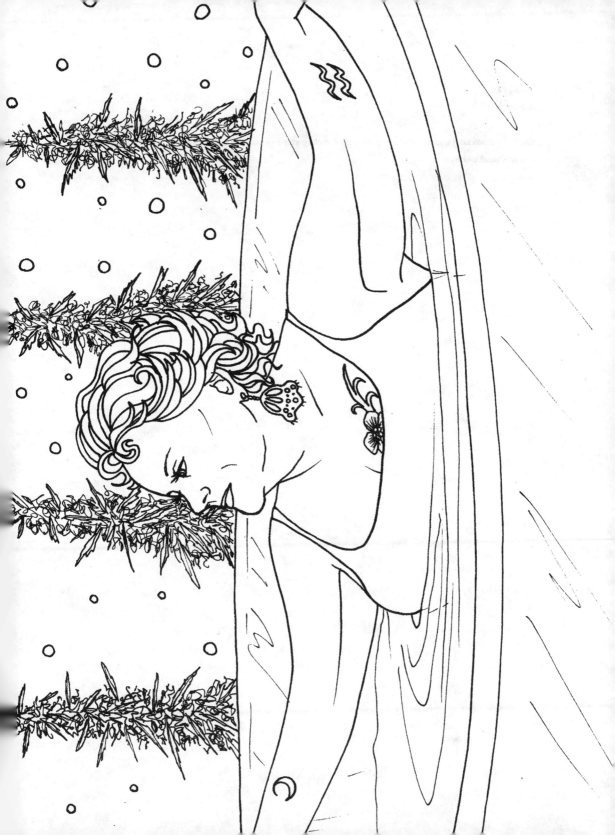

Trish
Aquarius

Empowerment to me is recognizing and using my resources and gifts for the betterment of myself and others.

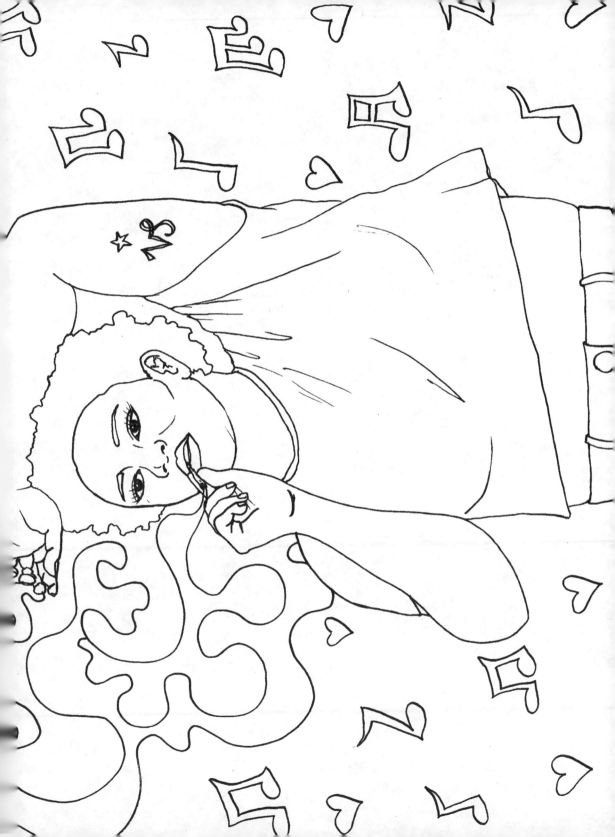

Kanda

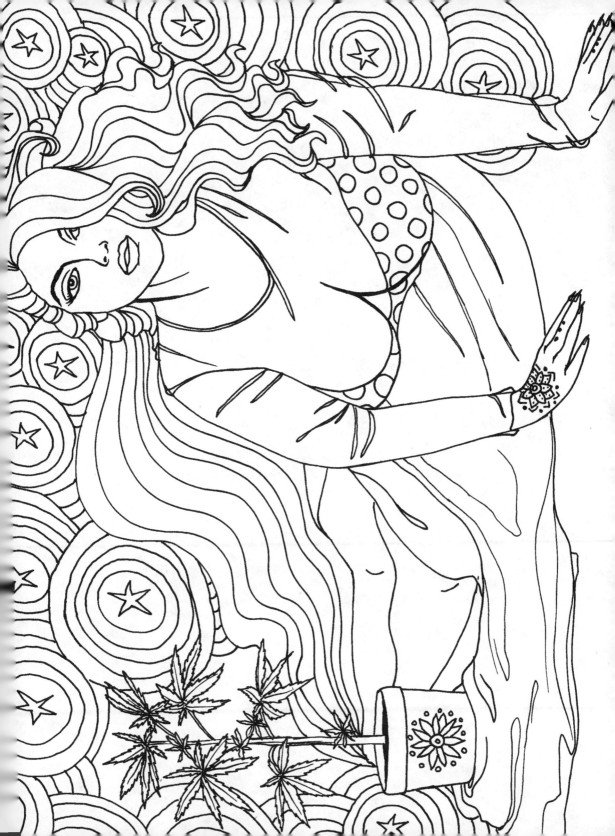

Katana Fatale

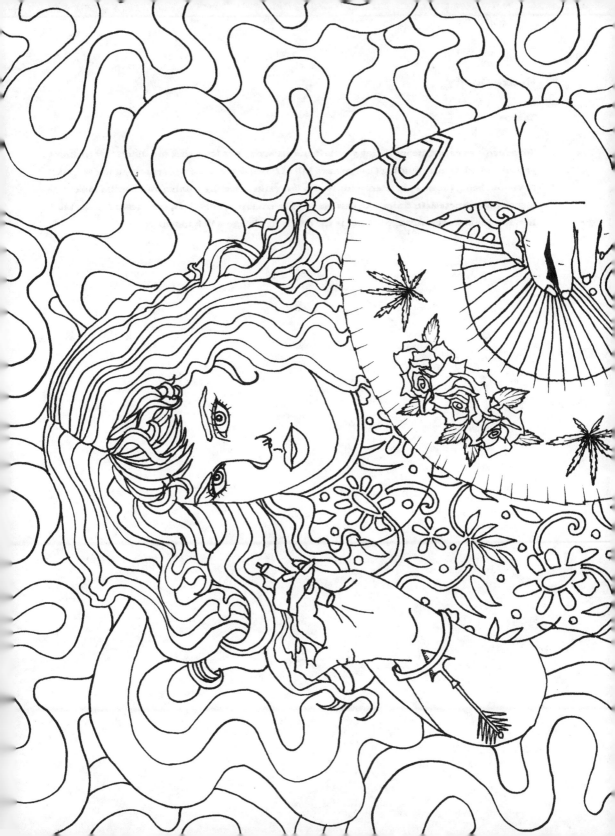

Claire Doody

Taurus

To me empowerment means lifting yourself and others up to a level that you didn't always know you embodied. Understanding that you are full of hope, determination, tenacity and drive. It is not about being the most boisterous or heard, but rather steadily gaining momentum to become bigger than yourself. In times like this we need to empower ourselves, our communities, families, friends and even strangers. That is the only way change will happen.

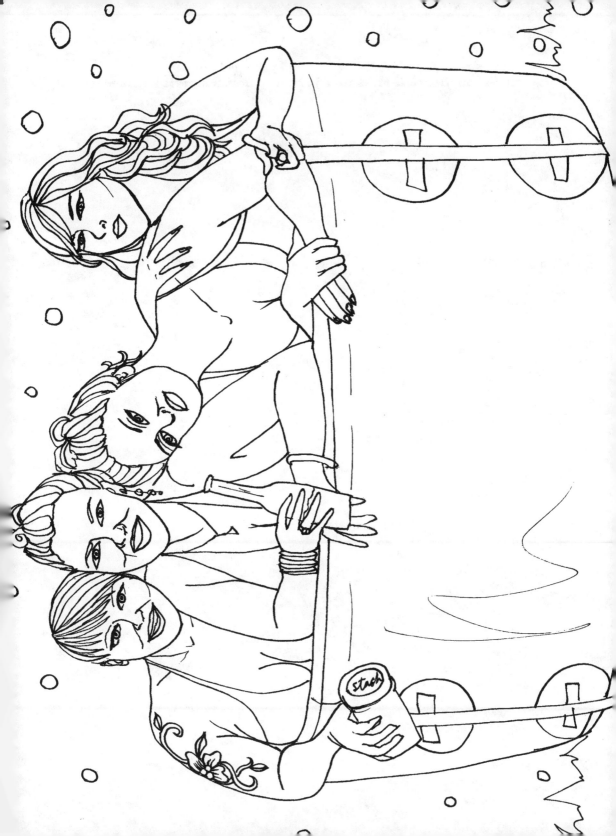

Katie Guinn, Danielle Meskill, Aja Mehki, Sarah Morris Kemper

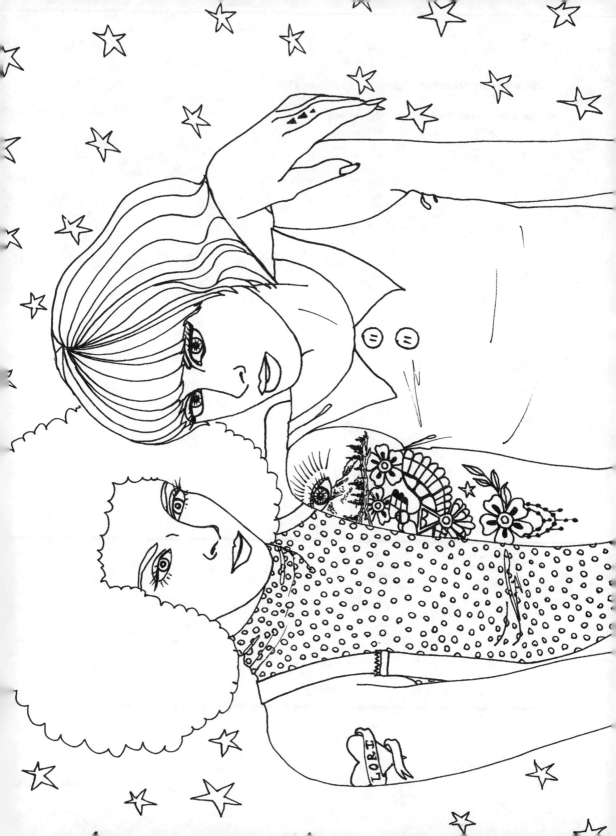

Skye Sengelmann Sintora, Tashina Hill

Based on a photo by Amanda Leigh Smith

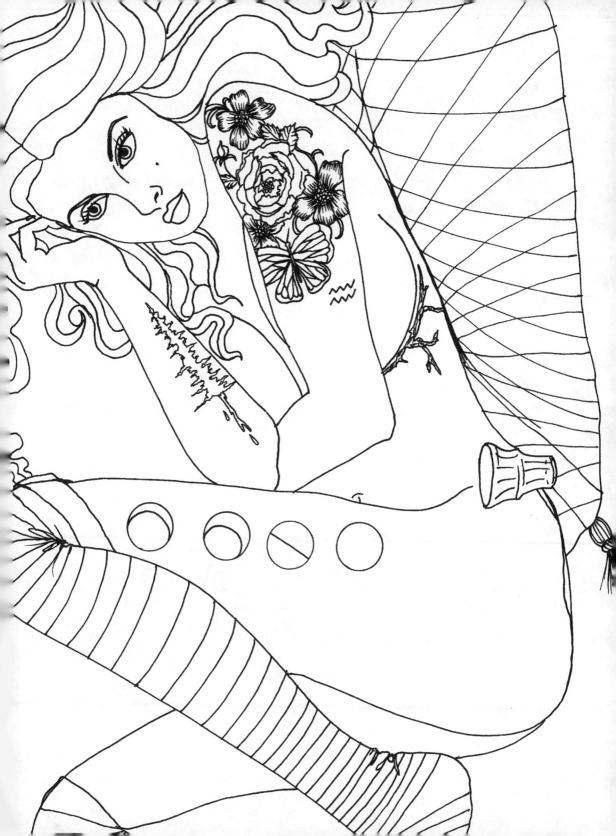

Luna

Aquarius

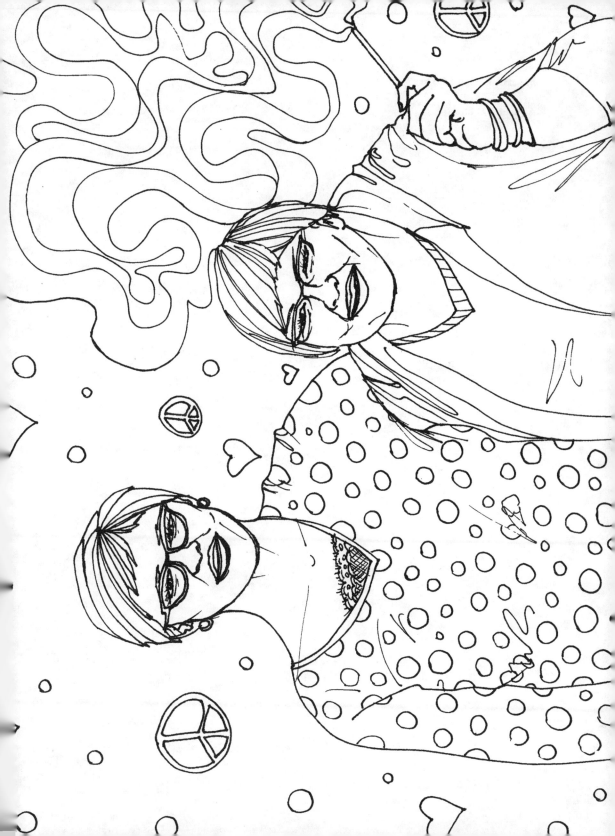

Mama Lulie & Jan

Aquarius & Libra

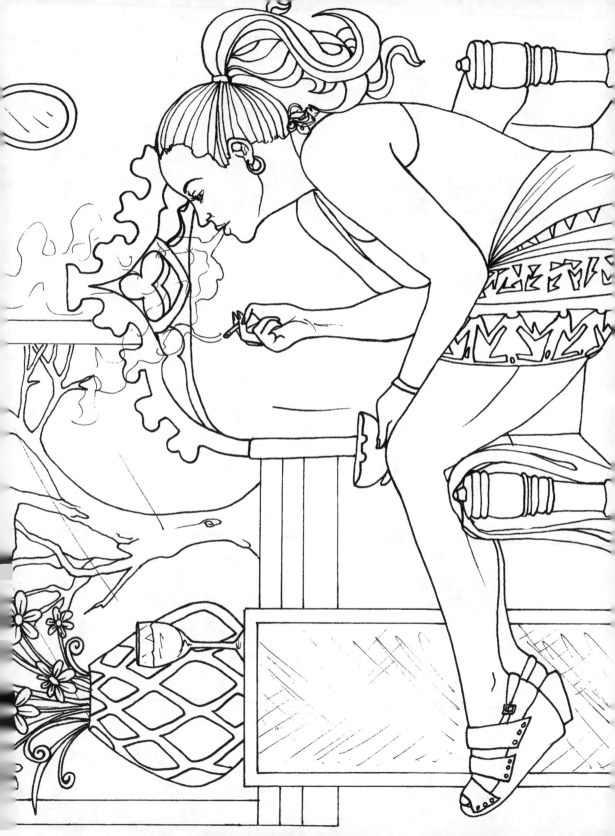

M.J.

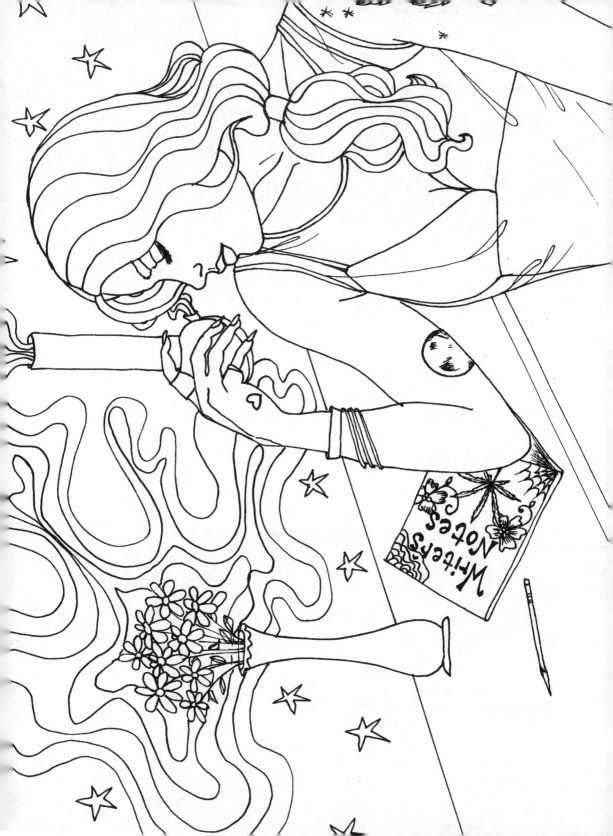

Skye Sengelmann Sintora

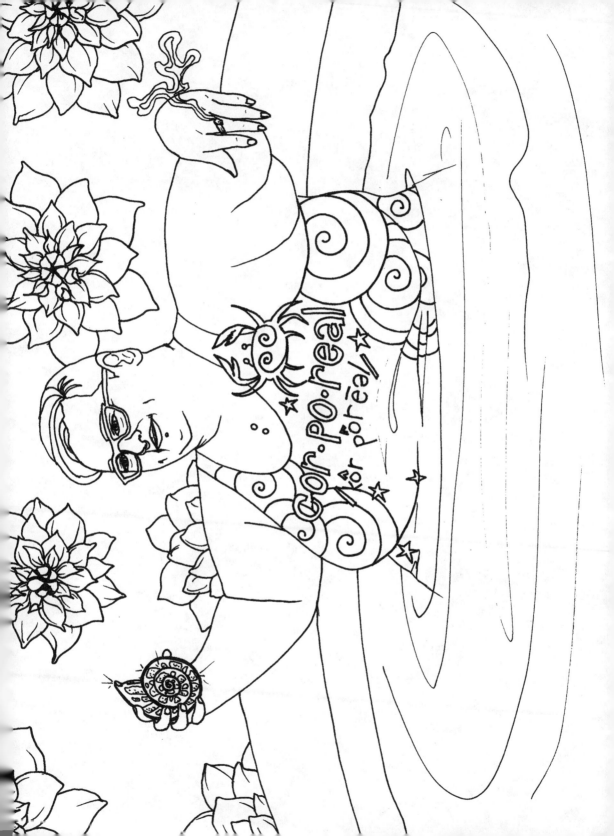

cor·po·real
(kôr pôr'ē əl)

Stoner Boi Domi

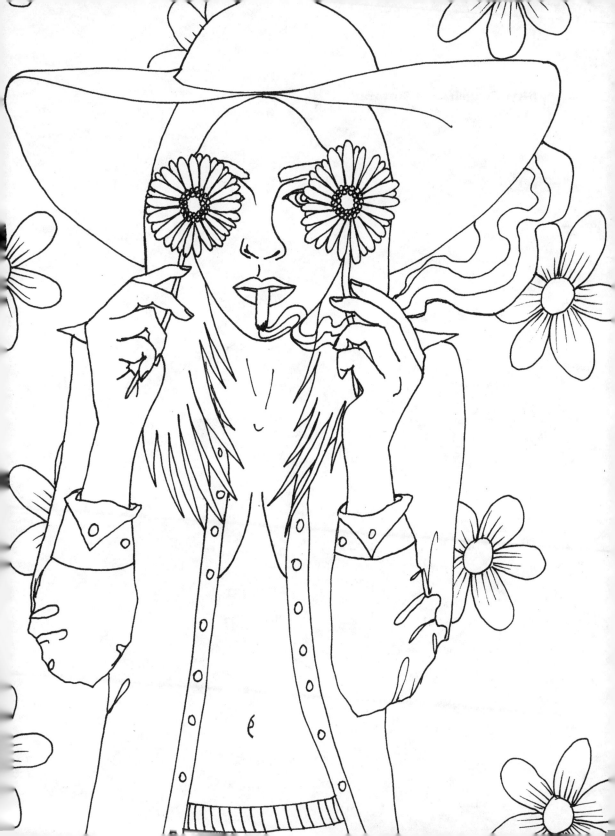

Skye Sengelmann Sintora

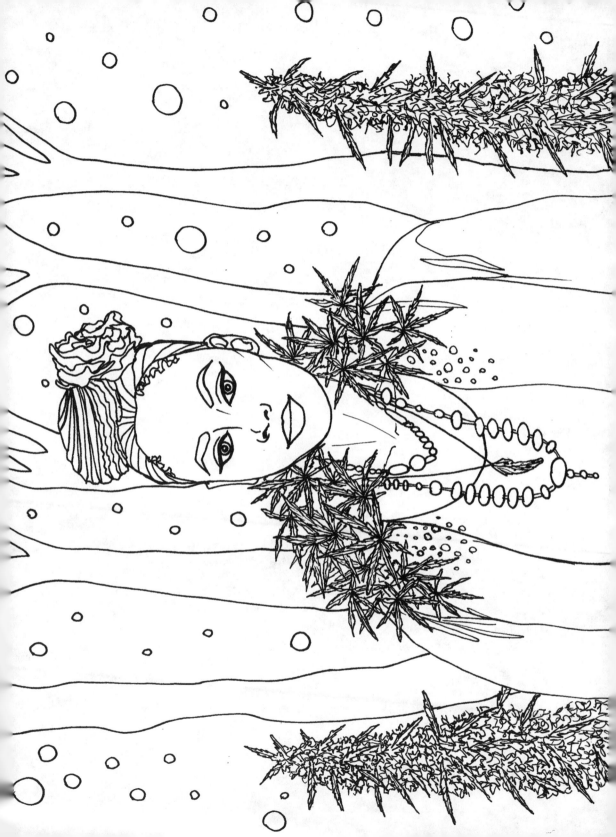

Sy Sylvers

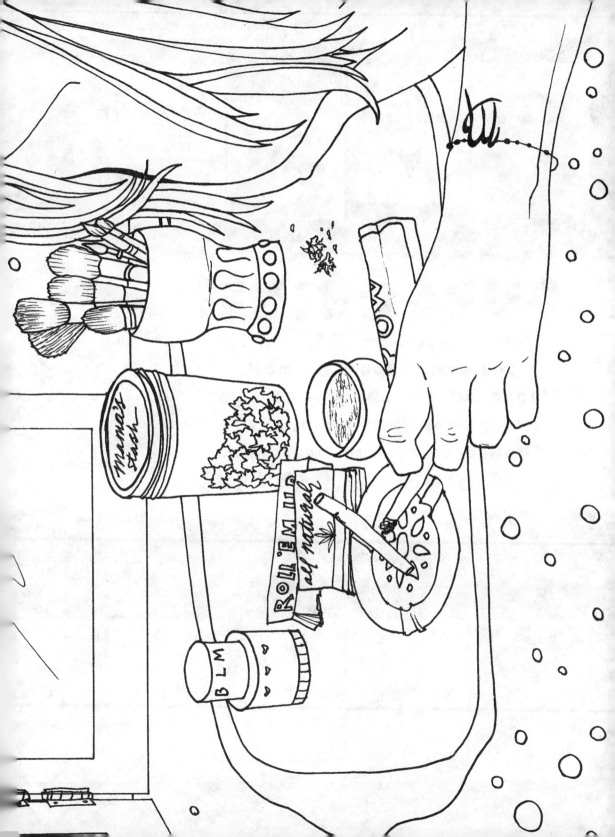